MASTERPIECES FROM
THE ROBERT von HIRSCH SALE
AT SOTHEBY'S

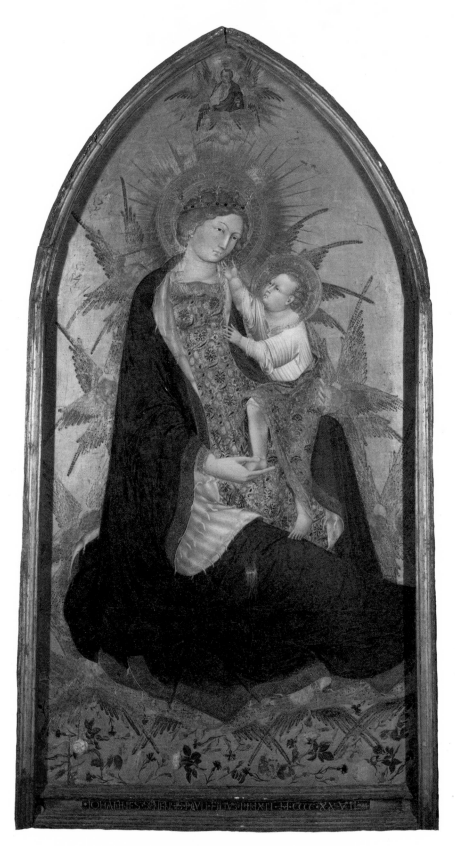

Giovanni di Paolo; The Branchini Madonna (page 43)

MASTERPIECES FROM THE ROBERT VON HIRSCH SALE AT SOTHEBY'S

with an article on The Branchini Madonna
by Sir John Pope-Hennessy

SOTHEBY PARKE BERNET

FOREWORD

The world-wide interest in the von Hirsch sales, and the great demand for catalogues, have prompted us to produce a book illustrating a selection of masterpieces from the collection together with the full catalogue descriptions, the prices and the final destinations of some of the works of art.

For more than one hundred years it has been the custom in this country for auctioneers to publish a second edition, together with the prices realised, of sales regarded as landmarks in the history of the art market. Following this tradition we have decided to publish a limited edition of fifteen hundred copies of a similar nature of the von Hirsch catalogues, together with a fifth volume containing tributes to Robert von Hirsch and illustrating pictures and drawings bequeathed by him to museums, to friends or to members of his family.

This present book however will, it is hoped, be of interest to many people who perhaps have not the specialised interest to require a complete record, with the prices realised, of the whole series of auctions.

The sale prices have been converted into dollars and DM at the rates effective during the sale.

CONTENTS

© Sotheby Parke Bernet & Co 1978

First published 1978 for Sotheby Parke Bernet Publications by
Philip Wilson Publishers Limited
Russell Chambers, Covent Garden, London WC2E 8AA, and
81 Adams Drive, Totowa, New Jersey 07512

ISBN 0 85667 060 X (hardback)
ISBN 0 85667 061 8 (paperback)

Printed and bound in Great Britain by Westerham Press Ltd and Mansell Bookbinders Ltd

ROBERT von HIRSCH
1883-1977

Robert von Hirsch, the last surviving member of the generation of connoisseurs, collectors

and scholars which included such august names as Berenson, Bode, Friedländer, Offner, von Falke and Mayer, died in Basel at the age of ninety-four on November 1st of last year.

Born in Frankfurt in 1883, as a young man he entered the leather firm of his uncle. Robert Hirsch, as he then was, soon proved himself as a businessman and brought the Offenbacher leather firm to such international fame that in 1913 even the Tzarina and her brother, the Grand Duke of Hesse, paid an official visit to the factory. The Grand Duke, himself a patron of the arts, showed his appreciation of Robert Hirsch's work by honouring him with a title and the right to add the prefix von to his name.

Initially with his elder brother he collected French and German first editions many of which were in fine bindings and inscribed. In 1905, at the age of twenty-two, Robert von Hirsch met Georg Swarzenski, the newly appointed director of the Städelsche Kunstinstitut. Swarzenski aroused in the young businessman a great interest in the arts; it was under his guidance, and later that of the head of the Städelsche's Print department, Edmund Schilling, that Robert von Hirsch built up his collection. The first painting he bought in 1907 was *La Rousse au Caraco blanc* by Henri de Toulouse-Lautrec; his next purchase the *Scène de Rue* by Pablo Picasso. This was the period when Thoma, Liebermann, Leibl and the works of Dutch nineteenth century painters were being collected in Frankfurt. He purchased a property on the Bockenheimer Landstrasse and travelled widely with Swarzenski, gaining a remarkable and wide-ranging knowledge of the arts.

During a remarkably short period in the late 1920s and early 1930s, Robert von Hirsch assembled his unrivalled collection of Medieval and Renaissance works of art from the Hohenzollern-Sigmaringen collections, the Guelph Treasure and the Hermitage sales.

In 1925 he lent twelve important paintings for an exhibition of Old Master paintings in Frankfurt. His house, a focal point of the art world, was renowned for its hospitality. In 1930 he was made an administrator at the Städelsche Kunstinstitut.

When, a few years later, the political climate in Germany and the possible personal consequences it might entail became apparent to him, he transferred his business interests to Basel. Very soon after January 30th, 1933, he applied for permission to emigrate with his entire collection. As a condition for the export of an important painting, *The Crucifixion of Christ* (School of Cologne, 1340), which years before had been declared a property of national interest, he had to donate Cranach's *Judgement of Paris* to Marshall Goering. While the latter was in fact restored to him after the war (still bearing the label 'The Property of the Reichsmarschall Goering') and bequeathed to the Kunstmuseum in Basel, *The Crucifixion* was sold in 1964 to the Wallraf-Richartz Museum in Cologne on the understanding that it would be delivered to the museum on the death of the collector, thus ensuring its return to its country of origin.

The house in the Engelgassè

In Basel, Robert von Hirsch made new friends, amongst them many musicians; but he kept up with his old friends, such as the former Frankfurt editor Fritz Gebler and other opponents of the German Reich who had found their way to that city. His friendships with Adolf Busch and Rudolf Serkin were to prove important to him.

The fame of the art collection at the Engelgasse spread, and museum directors and specialists from all over the world visited the house. Robert von Hirsch's knowledge of art was based on travel, study and much reading. Bernard Berenson, towards the end of his life, once declared to Michael Stettler that he had only met three collectors who actually knew about the things they were collecting and these were the two Stoclets and Robert von Hirsch. The reference library at the Engelgasse was of outstanding quality. Robert von Hirsch's interest in the Basel Kunstmuseum was soon aroused and he became a member of its board. During the war he could not be persuaded to go overseas and forsake the city of Basel to which he had formed a great attachment.

Shortly after the war he married the talented sculptress Martha Dreyfus-Koch, daughter of the Frankfurt jeweller. His collection began to reflect the taste of his wife. The faience collection of the Koch family and a modern dinner service by Lurçat

replaced the distinguished collection of Meissen porcelain. It was also his wife who created the renowned botanical garden.

The couple started to collect twentieth-century art of which, up to then, Picasso had been the only example. In the 1950s the magnificent collection at the Engelgasse included Ottonian ivories, medieval enamels, early Italian and German paintings, Renaissance bronzes, Dutch, German and Italian drawings, paintings and eighteenth-century furniture, masters of the Impressionist period and finally painters like Modigliani, Matisse and Soutine – a house full of treasures and a garden of rare and carefully selected trees, shrubs and alpines. It was hardly surprising that visitors from all over the world flocked to the house. Every year Robert and Martha von Hirsch travelled widely; they visited museums and art exhibitions, loved going to the theatre and concerts, and of course the Chelsea Flower Show.

After the death of his wife in 1965, Robert von Hirsch considered the future of his collection. The eighty-year-old collector believed in the free circulation of works of art and wanted his collection to be distributed on the market; but he also mentioned that relatives, friends and museums would inherit chosen pieces.

The Drawing Room at the Engelgassè

Many people feared that their old friend would become withdrawn and bitter after the premature death of his wife, but he saw to it that the hospitable house and the garden continued to be maintained in her honour. He made his yearly trips to Paris, Vienna and London and in his late eighties twice visited Kenya. He much enjoyed the company of Theodora von der Muhll, Dodi Staehelin, Peter Vischer, Werner Abegg, Hermann Fillitz, Michael Stettler and naturally enough Hanns Swarzenski, the son of his old mentor.

His frequent luncheon parties were famous. Guests of every nationality, and especially young people, were introduced into his circle. His clear sense of quality, his amiability and his lively sense of humour astonished his visitors.

If one tries to analyse his collection, one realises how much those things that were direct and unmannered meant to him. He loved the Impressionists. In his home, the wall covered with Cézanne watercolours probably provided him with the greatest joy.

Robert von Hirsch died clear of mind and little affected by illness. He will be remembered not least for his collection and the great joys it has given and will give to collectors.

<div style="text-align: right">J.G.W.</div>

THE BRANCHINI MADONNA BY GIOVANNI DI PAOLO

John Pope-Hennessy

At first sight *The Branchini Madonna* by Giovanni di Paolo from the Robert von Hirsch Collection looks like other Sienese fifteenth-century paintings. The central panel of an altarpiece painted for the chapel of the Branchini family in the church of San Domenico, it shows a Virgin of Humility supporting the Child at her side. Over her head is a small dove and above, at the apex of the panel, is God the Father in benediction. Only when we look at the painting more carefully do we become conscious of its singularity. The Virgin is indeed a Madonna of Humility but she is also represented as Queen of Heaven wearing a gesso crown and a cloak lined with ermine; she does not rest on the ground but is supported by four seraphim whose wings protrude beneath her dress. Indeed, properly speaking there is no ground on which she could reasonably be sitting, for the base of the painting is strewn with flowers with severed stems. The seraphim continue above, three at each side, their wings outstretched against the gold background. The original blue surface of the Virgin's cloak has been renewed – it seems to have been reduced to its present form between 1904, when the panel was in the Chigi-Saracini Collection, and the time of its purchase for the von Hirsch Collection which was not later than February 1923 – but the edge of the ermine lining is original and falls with extraordinary elegance and freedom. The ermine tails break what might otherwise have been a hard uninterrupted line and are visible once more at the base on the right and at a point on the left where the cloak is turned back on itself.

That the image has a rather special devotional intention is confirmed by the inscription in the Virgin's halo, *HIC QUI TE PINXIT PROTEGE VIRGO VIRUM* (Protect, O Virgin, the man who has painted thee), the more so that the name of 'the man who has painted thee' appears beneath on the frame: *JOHANNES SENENSIS PAULI FILIUS PINXIT MCCCCXXVII*. The most notable precedent for such an inscription occurs not in a halo but on the step of the central panel of Duccio's *Maesta* where the painter's name is also associated with an invocation to the Virgin: *MATER SCA DEI/SIS CAUSA SENIS REQUIEI/SIS DUCCIO VITA/TE QVIA PINXIT ITA*. The flowers at the bottom of the present panel are attributes of the Virgin and include white roses, marigolds and cornflowers.

The 1420s in Tuscany were a period of stylistic revolution. In Florence the innovators were two sculptors, Donatello and Ghiberti, and four painters, Gentile da Fabriano, the young Fra Angelico, Masolino and Masaccio; in Siena they were a sculptor, Jacopo della Quercia, and three painters, Domenico di Bartolo, Sassetta and Giovanni di Paolo. The interconnection between the two centres must have been much closer than modern art historians allow. Jacopo della Quercia may have worked in Florence; Domenico di Bartolo is traditionally supposed to have painted the high altarpiece for the church of the Carmine;

Ghiberti seems to have been responsible for the design of the base of the baptismal font in San Giovanni in Siena and visited the city repeatedly in connection with this work, and in 1425 Gentile da Fabriano, his Florentine commissions completed, moved to Siena on his way to Orvieto and Rome. There is no evidence that Giovanni di Paolo visited Florence before 1427, though he must have done so in the 1430s when he studied the Florentine works of Gentile and Fra Angelico, but he was closely associated with Gentile da Fabriano in Siena in 1425. The work commissioned from Gentile for Siena, the so-called *Madonna dei Notai*, has disappeared, but we can form an impression of its general character from the two great altarpieces he produced in Florence immediately before, *The Adoration of the Magi* for the Strozzi Chapel of Santa Trinità and the Quaratesi Polyptych for San Niccolò, as well as from the small *Virgin and Child with Saints* of the same date, now in the Frick Collection. The idiosyncrasies of these three paintings, their linear rhythms, their firm modelling, their latent naturalism and their opulent decorative style are all reflected in Giovanni di Paolo's earliest works.

The first work by Giovanni di Paolo that we know, the Pecci altarpiece, dates from a year before the von Hirsch *Madonna* and was also painted for the church of San Domenico. The central panel, a *Madonna and Child enthroned with angels*, is now in the church at Castelnuovo Berardenga and two of its side panels are in the Pinacoteca at Siena. Its central group derives from that in an altarpiece painted by the leader of conservatism in Siena, Taddeo di Bartolo, in 1400 for the chapel of Santa Caterina della Notte, but the differences between them, the cursive line of the Virgin's cloak, the soft inclination of her head and the decorative music-making angels disposed in the depth at the two sides, are the first fruits of Giovanni di Paolo's contact with Gentile. At the front is an entirely novel feature, a pavement of large foliated tiles with orthogonals directed not centrally but towards the left of the panel. Three of the tiles show thistles, a symbol of the Passion of Christ, and four represent a small plant, perhaps a daisy. The tiles are fanciful, insofar as no tiles of this type produced in Italy at so early a date are known, but they reflect the influence of Gentile and look forward to the floreated base of the panel on which Giovanni di Paolo started work as soon as the Pecci altarpiece was complete.

The influence of Ghiberti in Siena has not been adequately analysed. His first recorded contacts with the city date from 1416 and 1417 when he paid three visits in connection with the designing of the baptismal font. Despite repeated urging, his two bronze reliefs were still unfinished in 1425 and were completed only in 1427. The linear rhythms in the work of the young Giovanni di Paolo, especially in the von Hirsch *Madonna*, bear a direct relation to one of these reliefs, *The Baptism of Christ*.

One of the most beautiful features of the von Hirsch *Madonna* is the Child, who is shown standing with his left leg extended on the Virgin's thigh. His right foot rests on her hand and his right arm reaches up diagonally in an unsuccessful effort to touch or stroke her face. There is no precedent for this beautiful figure in Sienese painting but it has parallels in Florence in the work of Masolino who in 1423, in a well-known *Madonna*, now at Bremen, depicted the Child with his left foot on the Virgin's knee, the other in the Virgin's hand and his left arm thrown

round her neck. A few years later, in a *Madonna* (now lost but known from photographs) which was once at Novoli and which formed part of an altarpiece in Santa Maria Maggiore, a climbing Child is again shown, this time clothed; his feet and head are disposed much as they are in Giovanni di Paolo's painting with the right elbow bent against the Virgin's neck. Possibly Giovanni di Paolo knew these paintings at first hand but nowhere is the relationship so clear as to compel us to believe that this was so and it is far more likely that they have a common source in a terracotta by Ghiberti.

About 1430 both in Florence and Siena, for reasons that cannot be reconstructed, the springs of inspiration started to dry up. When Gentile da Fabriano's Quaratesi predella was copied by Bicci di Lorenzo, what was imitated was its content not its style. With Masaccio's death in 1428 work in the Brancacci Chapel came to a sudden halt and thereafter his style, or such aspects of it as were apprehensible, was translated into terms of decoration by Fra Filippo Lippi, while in Siena after 1432 Sassetta retreated from the *Madonna of the Snow* to the pinched, schematic forms of the *Madonna* from the Borgo San Sepolcro altarpiece, now in the Louvre. With Giovanni di Paolo, a less great painter but doctrinally a more serious, more committed artist, the same process occurs, first in the fragments surviving from the Fondi altarpiece in Siena, now at Houston and in the Metropolitan Museum, and then in the third of his polyptychs for San Domenico, the Guelfi altarpiece of 1445 which is now in the Uffizi. Impressive his later works unquestionably are, but when confronted by their jagged silhouettes how fervently one wishes that he had painted other works as yielding, as graceful, as tender as the von Hirsch *Madonna*.

Reproduced from *Art at Auction 1977–78*,
The Year at Sotheby Parke Bernet

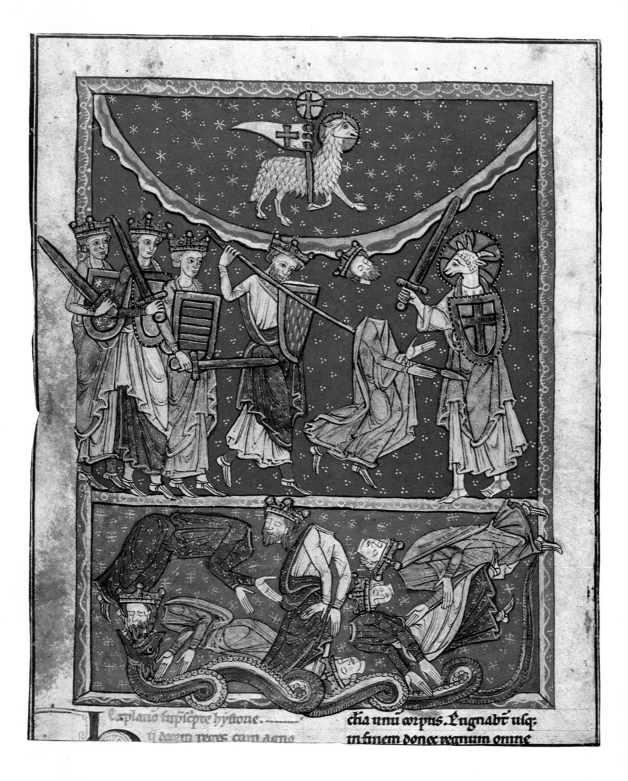

Large illuminated miniature in two compartments, in the upper one the Lamb, dressed as a warrior, kills the first of the five kings of the earth whom he will overcome, above is the victorious lamb in Heaven, deep blue starry ground, in the lower compartment the Beast "that was and is not" devours the five kings, red ground, *on* VELLUM, *painted in full colour, principally pale brown, green, blue, orange and red, with tracery in white and illumination in both gold and silver, two lines of text and fragment of initial below miniature, on the verso (which preceded the miniature in the bound manuscript) 33 lines of text in a late romanesque hand, headings and line-fillers in red, large initial (4-line) in blue with infilling in red and green, part of text trimmed at foot, very fine condition, framed.*

11$\frac{9}{16}$in. × 9$\frac{1}{4}$in. 29.4cm. × 23.5cm.

[Northern Spain, *circa* 1200].

This is a long-lost leaf of the celebrated Bibliothèque Nationale ms. nouv. acq. 2290, Beatus on the Apocalypse, which was bought in Paris in 1882. That manuscript has the late medieval ownership inscription of the 12th-century Cistercian nunnery of Saint-André d'Arroyo, diocese of Palencia, to which, according to J. Domínguez Bordona (*Spanish Illumination*, I, Florence, 1930, p. 24), it may have been presented about 1389 by Charles III of Navarre. The manuscript was compared by Delisle with the Apocalypse of St-Sever (*Manuscrits latins et français ajoutés au fonds des nouveaux acquisitions pendent les années 1875–1891*, p. 43) and is discussed by P. Lauer ("ce magnifique travail... un très grand effort d'invention") in *Les Enluminures Romanes des Manuscrits de la Bibliothèque Nationale*, Paris, 1927, pp. 154–65, col. pls. D–E and pls. XXVIII–XXX. The present leaf is that missing after f. 145 in the Bibliothèque Nationale manuscript.

The great commentary on the Apocalypse by Beatus of Liébana (*d. circa* 798) was regarded as the most precious book in a Spanish romanesque monastery. The present leaf contains the commentary for Apocalypse 17:13–18 (pp. 571–2 of H. A. Sanders, *Beati in Apocalipsin Libri XII*, Papers and Monographs of the American Academy in Rome, VIII, Rome, 1930). Four lines of text originally followed below the miniature. The manuscript belongs to Sanders's Second Category and is MS. C in his classification (*ibid.*, p. xiii).

PROVENANCE:
Eugène Rodriguez; his sale, Müller, Amsterdam, 11–13 March 1921, lot 243.

LITERATURE:
G. Swarzenski, "Ein Einzelblatt aus einer romanischen Apokalypse" *Städel-Jahrbuch*, II, 1922, pp. 5–10, pl. I (in colour).
G. Swarzenski and R. Schilling, *Die Illuminierten Handschriften und Einzelminiaturen des Mittelalters und der Renaissance in Frankfurter Besitz*, Frankfurt-am-Main, 1929, p. 35, no. 38, pl. XIX.

£45,000 $82,575 DM172,687 (lot 4)

MASTER OF ST. VERONICA (Circle of).

The Crucifixion, the Virgin, three women and St. John on the left, the centurion gesticulating to two men on the right, *with* St. Anthony the Abbot blessing domestic animals assembled round his daïs, groups of laymen on either side, both miniatures with diaper grounds and arched gothic canopies, *on* VELLUM, *painted in full colour and gold, versos blank, cut to shape, two extremely small wormholes in one leaf, otherwise in extremely fine condition, framed.*

Each 9¼in. × 4¾–4¹⁵⁄₁₆in. 23.6cm. × 12–12.5cm.
[Cologne, *Circa* 1405].

The Veronica Master, to whose own hand Zehnder attributes these extremely fine miniatures, is described (*Late Gothic Art from Cologne*, National Gallery, London, 1977, p. 30) as "the most important painter in Cologne before the time of Stephen Lochner". This pair of miniatures belongs to the Master's immediate circle and the composition of the Crucifixion is extremely close to the Veronica Master's small Calvary in the Wallraf-Richartz Museum (no. 14). The designs too are related to panel paintings by the Master of St. Laurence such as his large Passion (*Late Gothic Art*, no. 10) and to manuscripts associated with that Master (cf. *ibid.*, no. 43). Mrs. Spriggs draws attention to the close relationship between the work of the Veronica Master and the miniatures painted in England by Herman Scheerre, and these two miniatures provide a valuable link between the Cologne panel painters and the manuscript illuminators. The present Crucifixion is not far from those in the Nevill Hours and the Lapworth Missal (Spriggs, pls. 26b and 29e) and the diaper background is found in both English and Cologne miniatures. Attempts to identify the Veronica Master with Master Hermann Wynrich of Wesel (whom others link in turn with Herman Scheerre) have not gained general acceptance. The present miniatures are exceptional in their fine colour and composition and show the influence in Cologne of Parisian court painting and perspective.

The rare depiction of St. Anthony the Abbot (*d.* 356, aged 105) makes it likely that the miniatures come from a manuscript – or possibly a diptych – made for the newly consecrated hospital of St. Anthony, re-built in Cologne under Archbishop Friedrich von Saarwerden in the 1380's. St. Anthony is the patron saint of domestic and farm animals and there was a custom in the Cologne hospital of blessing domestic animals before the church door on St. Anthony's day.

LITERATURE:
G. Swarzenski and R. Schilling, *Die Illuminierten Handschriften und Einzelminiaturen des Mittelalters und der Renaissance in Frankfurter Besitz*, Frankfurt-am-Main, 1929, pp. 186–7, no. 154, pls. LXVI (colour) and LXVII.
A. Stange, *Deutsche Malerei der Gotik*, III, Berlin, 1934–58, pp. 81–2, pl. 97.
A. Boekler, *Deutsche Buchmalerei der Gotik*, Königstein-im-Taunus, 1959, pl. 39 (in colour).
F. G. Zehnder, "Der Meister der heiligen Veronika", *Vor Stefan Lochner. Die Kölner Maler von 1300 bis 1430*, exhib. Cologne, 1974, pp. 39 and 83 (reproduced p. 39).
G. M. Spriggs, "The Nevill Hours and the School of Herman Scheerre", *Journal of the Warburg and Courtauld Institutes*, XXXVII, 1974, p. 123, n. 58.

£90,000 $165,150 DM345,375 (lot 6)

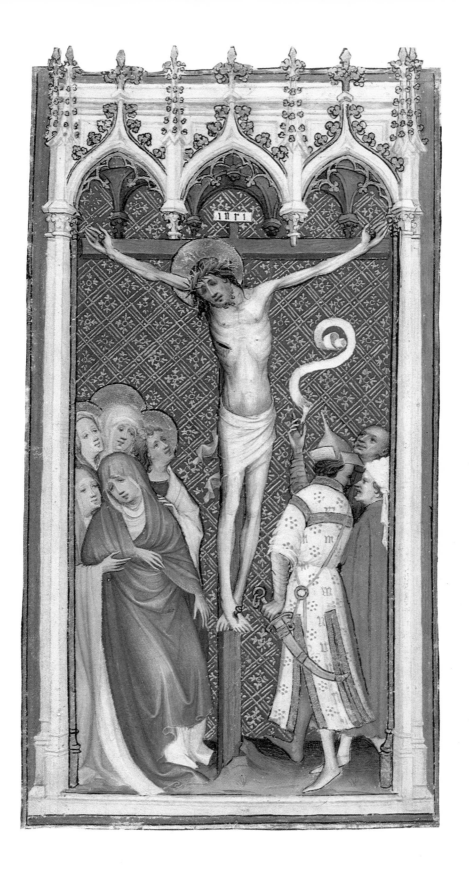

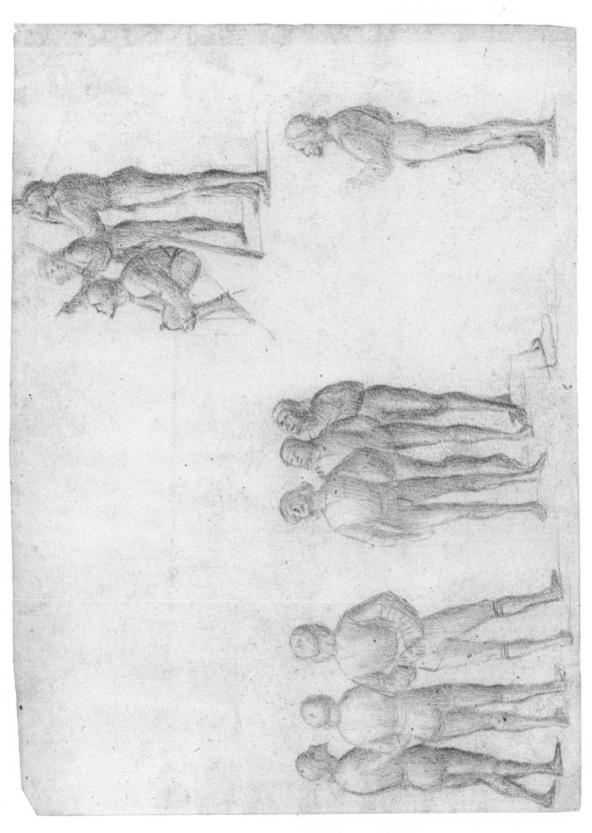

VITTORE CARPACCIO

Recto: STUDIES FOR THE LISTENERS IN THE "SERMON OF ST. STEPHEN"
Verso: SKETCH FOR A MARTYRDOM OF THE TEN THOUSAND CHRISTIANS (?)

Red chalk, *recto* and *verso*. The upper left corner missing.

$8\frac{5}{16}$in. × $11\frac{11}{16}$in. 21.1cm. × 29.6cm.

Jan Lauts was the first to notice that all the figures on the *recto* are preliminary studies for the audience (not yet wearing Oriental costumes) in *The Sermon of St. Stephen*, which formed part of the cycle in the Scuola di S. Stefano and is now in the Louvre, repr. Lauts pl. 159 and dated by him about 1514. The *verso*, as Hadeln (1925) and others have noticed is certainly a first hasty idea for the painting *The Martyrdom of the Ten Thousand Christians on Mount Ararat*, formerly in the church of Sant'Antonio di Castello and now in the Accademia, Venice, repr. Lauts pl. 179 and dated by most scholars 1515.

PROVENANCE:
Sunderland.
John Postle Heseltine (L.1507).
Henry Oppenheimer, his sale, Christies, 10–14 July, 1936, lot 52.

LITERATURE:
Sidney Colvin, *Über einige Zeichnungen des Carpaccio in England, Jahrbuch der Königlich Preussischen Kunstsammlungen*, Berlin, 1897, p. 194.
Gustavo Ludwig and Pompeo Molmenti, *Vittore Carpaccio: la Vita e le Opere*, Milan, 1906, p. 284 (*verso*) and p. 286 (*recto*) both reproduced.
Joseph Meder, *Die Handzeichnung*, Vienna, 1919, p. 288, 289, pl. 97 *verso* repr.
Vasari Society for the Reproduction of Drawings by Old Masters, 1913–14, part IX, nos. 6 and 7.
Detlev von Hadeln, *Venezianische Zeichnungen des Quattrocento*, Berlin, 1925, pp. 58, 59, pls. 37 and 38.
Giuseppe Fiocco, *Carpaccio*, 1930, p. 70, pl. CLXX a/b; 1931 ed., p. 84, pl. CLXX a/b.
Raymond van Marle, *The Development of the Italian Schools of Painting*, vol. XVIII (1936), p. 345.
Hans Tietze and Erica Tietze-Conrat, *The Drawings of the Venetian Painters*, 1944, no. 623 (*verso*).
Giuseppe Fiocco, *Carpaccio*, Novara, 1958, p. 33.
Jan Lauts, *Carpaccio*, London, 1962, p. 263, pl. 163 (*recto*), pl. VII b (*verso*).
Pietro Zampetti, *Catalogo della Mostra Vittore Carpaccio*, Venice, Palazzo Ducale, 1963, pp. 250–251 under no. 54.
Terisio Pignatti, *Master Drawings (Review of Lauts Carpaccio)*, 1963, no. 4, p. 53.
Manlio Cancogni, *L'Opera Completa del Carpaccio*, Milan, 1967, under nos. 56 and 61, both reproduced.

£42,000 $77,070 DM161,175 (lot 19)

BERNARDINO DI BETTO called PINTORICCHIO

HEAD OF A YOUTH LOOKING UPWARDS

Metal point, heightened with white on pinkish-grey prepared paper. Inscribed in brown ink by Zanetti on the backing: *Ritratto di Raffaele d'Urbino/Giovine./fatto di sua propria/mano, quando era in/ Scola di Pietro Perugino/suo maestro.*

10in. × 7⅝in. 25.5cm. × 19.4cm.

This is one of a very small group of drawings that can be firmly attributed to Pintoricchio. Fischel (1917) compares it with two similar painted portraits, one in the National Gallery of Art, Washington (see National Gallery of Art, *Illustrations* 1968, no. 405), the other in Dresden, (see Henner Menz, *The Dresden Gallery*, 1962, pp. 90–1).

PROVENANCE:
Antonio Maria Zanetti (L.2992f).
Darmstadt, Kupferstichkabinett.

LITERATURE:
Schönbrunner-Meder, *Handzeichnungen Alter Meister aus der Albertina und anderen Sammlungen*, 1908, V, no. 552.
Oskar Fischel, *Die Zeichnungen der Umbrer*, Berlin, 1917, p. 203, no. III, pl. 278.
Stift and Feder, 1928, no. 12.

£65,000 $119,275 DM249,437 (lot 22) The Woodner Family Collection

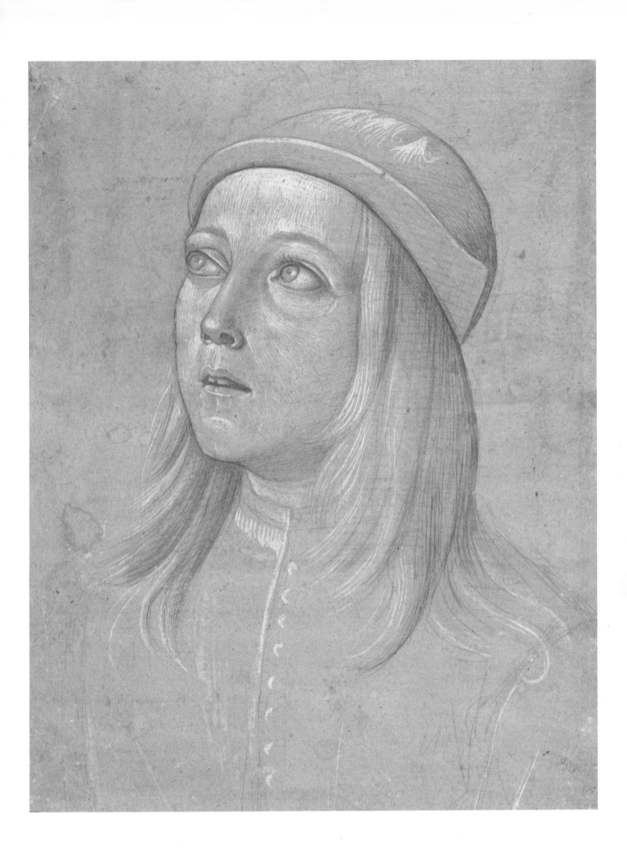

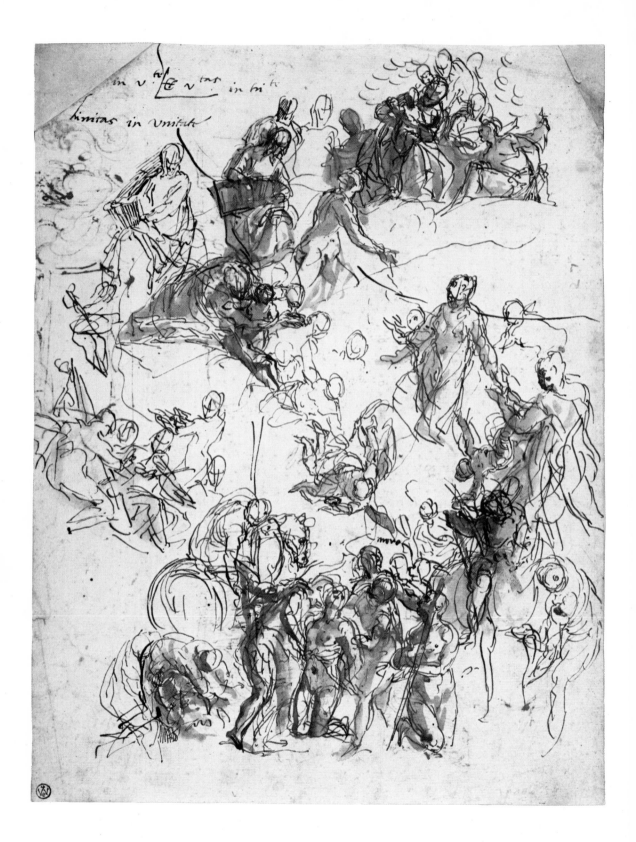

PAOLO CALIARI called PAOLO VERONESE

SHEET OF STUDIES FOR THE MARTYRDOM OF ST. GEORGE

Pen and brown ink and wash. Inscribed by the artist: *trinitas in unitate* and *moro*, etc. Top corners missing.

11¾in. × 8⅝in. 28.9cm. × 21.9cm.

The studies on this sheet are first ideas for Veronese's altarpiece in San Giorgio, Verona. Professor Pignatti dates the painting 1566. Richard Cocke has drawn attention to another study for this altarpiece in the Boymans Museum, Rotterdam, cf. Cocke, 1973, pl. 2.

PROVENANCE:
Freiherr Max Heyl zu Herrnsheim (L.2879).
Emile Wauters (L.911), his sale, Amsterdam, Müller, 15–16 June, 1926, lot 33, illus.

LITERATURE:
Frederic Lees, *The Art of the Great Masters, as exemplified by drawings in the collection of Emile Wauters*, 1913, p. 49, fig. 65.
Tancred Borenius, *A Group of Drawings by Paul Veronese, Burlington Magazine*, February, 1921, p. 54.
Detlev von Hadeln, *Venezianische Zeichnungen der Spätrenaissance*, 1926, pl. 24.
Percy H. Osmond, *Paolo Veronese, his Career and Work*, 1927, p. 54, p. 100.
Giuseppe Fiocco, *Paolo Veronese*, 1928, p. 210.
Hans Tietze and Erica Tietze-Conrat, *The Drawings of the Venetian Painters*, 1944, and reprinted 1970, no. 2029.
Richard Cocke, *Observations on some drawings by Paolo Veronese, Master Drawings*, vol. XI, no. 2 (1973), p. 138–9, pl. 3.
Terisio Pignatti, *Veronese*, 1976, p. 131, under no. 161, illus. fig. 424.

£75,000 $137,625 DM287,812 (lot 26)

URS GRAF

A MAN HOLDING AN ASTRONOMICAL INSTRUMENT

Pen and black ink. Signed in black ink: *VG* and with the goldsmiths "borax box".

$7\frac{9}{16}$in. \times $5\frac{1}{8}$in. 19.2cm. \times 14.8cm.

An early work dated by Parker, *circa* 1508. It is one of Graf's finest portrait drawings and is signed with the detached initials and the borax box, emblem of the goldsmith's craft, which frequently forms part of his signature prior to 1511. It shows a young man in a fur lined houppelande, his head slightly tilted, eyes half closed against the dazzling sunlight, intent on setting his watch in accordance with the sun's position. The timepiece, which he has taken out of its brass case, is a *Concavum* (scil. horologium). The silver agraffe decorating his barret has the unusual form of an opening pea-pod. Barret-pins of this kind, embellished with human or animal figures, flowers, fruit, initials or even all sorts of familiar household objects, were part of fashionable dress in Graf's day.

Dr. Keopplin rejects Parker's theory that this is a companion piece to the Oppenheimer *Head of a Man*, now in the Basle print room.

A copy, corresponding exactly to this drawing, was last heard of in the collection of Erich Briess, New York.

PROVENANCE:
Count A. F. Andreossy.
Ambroise Firmin-Didot (Sale 1877, no. 26)
Paul Davidsohn, Berlin, 1839.
Stefan von Licht.
Edwin Czeczowiczka, Vienna, his sale, Boerner and Graupe, Berlin, 12 May, 1930, lot 83, pl. XXVI.

EXHIBITED:
Zurich, Kunsthaus, Landesausstellung, *Zeichnen/Malen/Formen*, 1939, no. 52.
Solothurn, Zentralbibliothek, 15 Nov–12 Dec., 1959.

LITERATURE:
K. T. Parker, *Urs Graf (c.1485–1527/8)*, *Old Master Drawings*, vol. I, no. 1, June 1926, p. 11ff., pl. 18 reproduced.
Walter Hugelshofer, *Swiss Drawings of the XV and XVI Centuries*, London 1928, p. 33, no. 23 reproduced.
H. A. Schmid, *Urs Graf: Der junge Mann mit der Sonnenuhr, das Werk, Schweizer Monatsschrift für Architektur,* ... August 1939, p. xvi ff. reproduced.
Emil Major and Erwin Gradmann, *Urs Graf*, Basle 1942, p. 15, pl. 2 reproduced.
Georg Schmidt and Anna Maria Cetto, *Schweizer Malerei und Zeichnungen im 15. und 16. Jahrhundert*, Basle [n.d.] pp. 31–33, pl. 51 reproduced.
Margarete Pfister-Burkhalter, *Urs Graf, Federzeichnungen*, Wiesbaden 1958/59, no. 1, pl. 1.
Hanspeter Landolt, *Swiss drawings in the early sixteenth century*, *The Connoisseur*, vol. 153, no. 617, July 1963, p. 172, reproduced.

£122,000 $223,870 DM468,175 (lot 13)

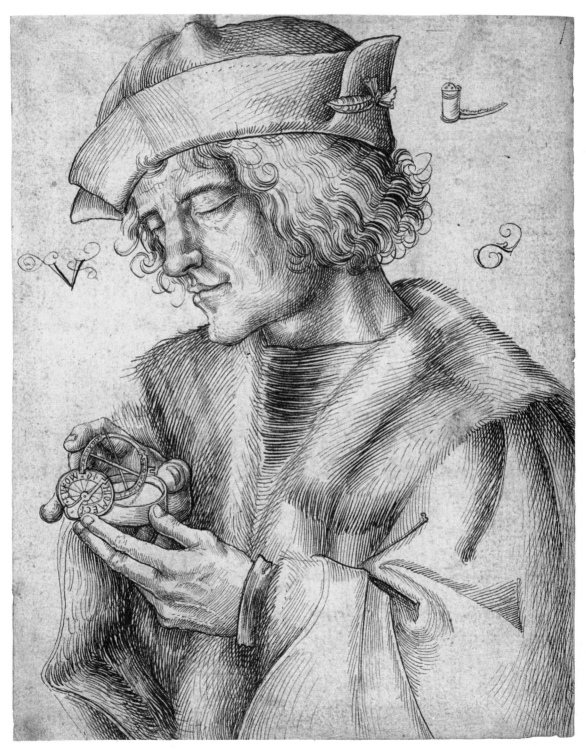

(actual size)

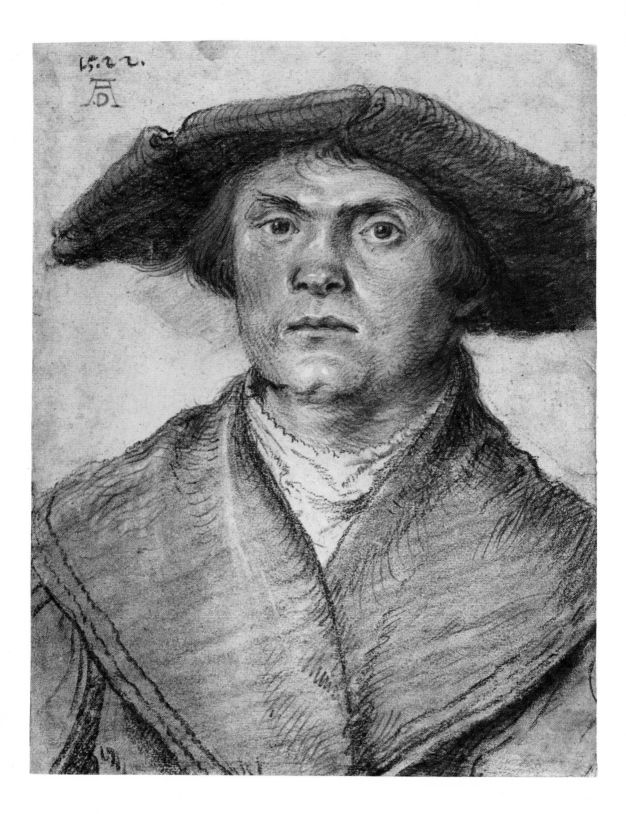

WOLF HUBER

PORTRAIT OF A MAN WEARING A SOFT BROAD-BRIMMED HAT

Black, red and white chalks. Dated in black chalk: *1522* and inscribed with a Dürer monogram which has been added at a later date.

$10\frac{7}{8}$in. $\times 8\frac{7}{16}$in. 27.6cm. \times 21.5cm.

This is one of the finest of Huber's recorded portrait drawings and claims particular interest as it was engraved and published in Joachim von Sandrart's biography of painters, the *Teutsche Akademie* of 1675 as the portrait of Mathias Grünewald. The drawing has also been thought to represent Martin Luther, however, both identifications are seriously doubted.

PROVENANCE:
Sir W. W. Knighton.
John Postle Heseltine.
Henry Oppenheimer, his sale, Christies, 10–14 July, 1936, lot 387.

LITERATURE:
John Postle Heseltine, *Original Drawings chiefly of the German School in the Collection of J.P.H [eseltine]*, London, 1912, no. 26.
The Vasari Society for the Reproduction of Drawings by Old Masters, Second Series, Part II, 1921, *The Oppenheimer Collection*, no. 16.
Frederick Winkler, *Dürers Grünewald-Bildnis, Belvedere*. VIII, Wien, 1925, p. 77.
M. Weinberger, *Wolfgang Huber, Deutsche Meister*, Leipzig, 1930, p. 126, pl. 70.
Edmund Schilling, *Altdeutsche Meisterzeichnungen*, 1934, pl. 33.
Wilhelm Fraenger, *Matthias Grünewald*, 1936, p. 62, reproduced p. 51.
W. K. Zülch, *Der historische Grünewald*, 1938, pp. 63–5, pl. 24.
W. Hugelshofer, *Wolf Huber als Bildnismaler, Pantheon*, XXIV, July 1939, p. 230.
Art News 47, New York, 1948, p. 48, no. 1 reproduced.
Erwin Heinzle, *Wolf Huber*, Innsbruck, 1953, no. 81, pl. 33.
Lisa Oehler, *Das Dürermonogramm auf Werken der Dürerzeit*, in *Städel Jahrbuch, Neue Folge*, Band, 3, 1971, p. 79ff. reproduced p. 88, pl. 11.

£105,000 $192,675 DM402,937 (lot 21)
Stadelsches Kunstinstitut, Frankfurt

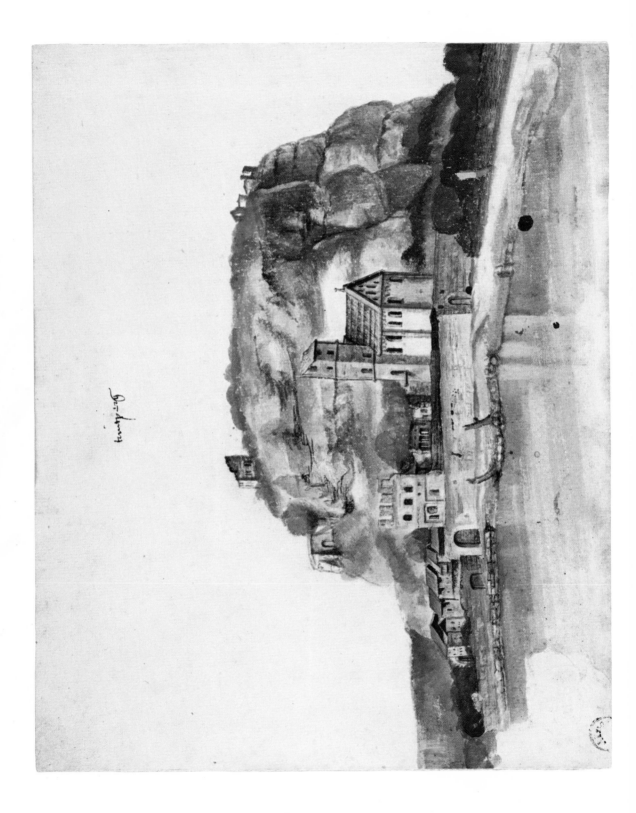

ALBRECHT DÜRER

THE ISOLATED ROCK OF DOSS TRENTO WITH THE ROMANESQUE CHURCH OF
ST. APOLLINARE DI PIEDICASTELLO

Watercolour and bodycolour. Titled by Dürer *"trintperg"*. Inscribed in pencil on
the verso: n^o *41.8z2L C 6z8L Hollar pag.128.*

$6\frac{5}{8}$ in. $\times 8\frac{3}{8}$ in. 16.8cm. \times 21.2cm.

One of only thirty-two watercolour-landscapes by Dürer and the last to remain in
private hands. It shows on the bank of the river Adige the steep (308ft. above the
city) rock called Dosso di or Doss'Trento with the ruins of its old fortifications.
Under it stands the small Romanesque church Sant'Apollinare di Piedicastello,
protected by a wall, which has hardly changed today. Instead of the river road
coming from the right from nearby Trent, we must today imagine the Adige flow-
ing from the north. The rock now bears a huge monument dedicated to the free-
dom fighter Cesare Battisti. The drawing's history is as follows. Heller (1831) saw
the drawing in Vienna, but mistakenly read the inscription as "Nurenberg"
instead of "trintperg". It subsequently disappeared until it was unearthed by
Alexander Dorner, before 1929 in the estate of the painter H. Schulz in Hanover.
He sent it to the Tietzes "but they declared it to be no more a Dürer than 'das
welsch schloss'" (now identified as Segronzano Castle and in the Berlin print
room, see Koschatzky 12). Winkler was then shown it and was able to find the
location through a modern photograph and the inscription which until then had
not been correctly read. Subsequently Dorner in the *Berliner Jahrbuch* for 1919
and the *Jahrbuch* (1933) was able to attribute it unequivocally to Dürer and this
has been accepted ever since. There is general agreement over its date, Pappen-
heim (1936), Dorner, Winkler and Panofsky (1948) believe that it must have been
executed, like the "View of Trent" (Bremen, Kunsthalle see Koschatzky 10) on
Dürer's return from Venice to Nuremberg in May 1495.

PROVENANCE:
Emperor Rudolf II, Prague (1552–1612)?
The Imperial Treasury, Vienna.?
The Court Library, Vienna?
Duke Albert von Sachsen – Teschen, Vienna (1738–1822)?
Françoise Lefèbvre, Vienna?
Joseph Grunling, Vienna (*circa* 1822) (L.1107).
H. Schulz, Hanover, died 1851.
Museum für Kunst und Landesgeschichte, Hanover.
Dr. Frits Nathan, Zürich, and Dr. Christoph Bernoulli, Basle.

(continued on page 29)

Doss Trento, 1932

LITERATURE:

Joseph Heller, *Das Leben und die Werke Albrecht Dürers*, Bamberg/Leipzig, 1831, vol. II, p. 129.

Alexander Dorner, *Ein unbekanntes Landschaftsaquarell von Dürer* in, *Jahrbuch der Preussischen Kunstsammlungen*, 1933, p. 29ff.

Gerola, *Die Entdeckung einer Zeichnung Dürers*, in *Il Brennero*, Trent, 9 Dec., 1932.

Albert Erich Brinckman, *Albrecht Dürer Landschaftsaquarelle* (Die silbernen Bücher), Berlin, 1934, p. 9.

Antonio Rusconi, *Per l'identificazione degli acquerelli tridentini di Alberto Durero*, in *Die Graphischen Künste, NF.* 1, 1936, p. 121ff.

Friedrich Winkler, *Die Zeichnungen Albrecht Dürers*, Berlin, 1936, vol. I, p. 72, no. 97.

Hans Eugen Pappenheim, *Dürer in Etschland*, in *Zeitschrift des Deutschen Vereins für Kunst-Wissenschaft*, 1936, Band 3, Heft, 1/2, p. 35ff., reproduced Abb. 7 on p. 44.

Hans Tietze and Erica Tietze-Conrat, *Kritisches Verzeichnis der Werke Albrecht Dürers*, Basle, 1937, vol. II–1, p. 13, no. 67a.

Erwin Panofsky, *Albrecht Dürer*, Princeton, 3rd ed., 1948, vol. II, p. 133, no. 1377.

Albert Erich Brinckman, *Albrecht Dürer, Landschaftsaquarelle*, Baden-Baden, 1949, p. 9, pl. 11, in colour.

Ludwig Grote *"Hier bin ich ein Herr" Dürer in Venedig*, Munich 1956, p. 12, pl. 4.

Angela Ottino della Chiesa, *The Complete Paintings of Dürer*, London, 1971, p. 90. no. 15.

H. Th. Musper, *Albrecht Dürer*, Cologne, 1971, p. 101, in colour, facing p. 21.

Kristina Herrman-Foire, *Dürers Landschaftsaquarelle*, Frankfurt, 1972, p. 11.

Walter Koschatzky, *Albrecht Dürer: the Landscape Water-Colours*, London, 1973, no. 8.

Walter Strauss, *The Complete Drawings of Albrecht Dürer*, New York, 1974, vol. I, p. 328 repr.

£640,000 $1,174,400 DM2,456,000 (lot 14) Unspecified German Museum

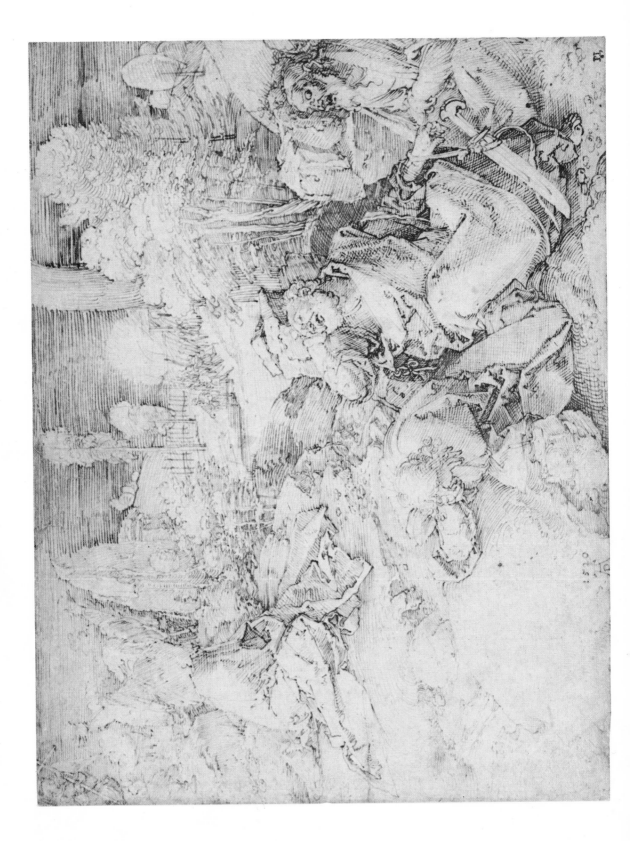

ALBRECHT DÜRER

CHRIST ON THE MOUNT OF OLIVES

Pen and brown ink. Signed in monogram and dated: *1520*. With a watermark similar to Briquet 1742 (*circa* 1500).

$8\frac{3}{16}$in. × 11in. 20.8cm. × 27.9cm.

Executed during Dürer's Netherlandish visit and one of the three mentioned in his diary on 26 May, 1521. It is the first of three preparatory studies for the projected *Oblong Passion*. The other two are both at Frankfurt, one dated 1521 (Winkler 798), the other, which is the most finished, dated 1524 (Winkler 891). The present drawing differs from each of them by the greater prominence given to the group of sleeping Apostles. A copy of this sheet is in the Louvre.

PROVENANCE:
Sir Peter Lely (L.2837).
Lord Hampton, Waresley Court.
P. and D. Colnaghi & Co. Ltd.

EXHIBITED:
Frankfurt, Städelsches Kunstinstitut, *Handzeichnungen alter Meister . . .*, 1924, no. 8.

LITERATURE:
Vasari Society for the Reproduction of Drawings by Old Masters, 1913–14, part IX, no. 21.
Georg Swarzenski and Edmund Schilling, *Handzeichnungen alter Meister aus Deutschem Privatbesitz*, Frankfurt, 1924, p. XI, no. 8.
Heinrich Wölfflin, *Die Kunst Albrecht Dürers*, Fünfte Auflage, Munich, 1926, p. 204, footnote 1.
Friedrich Lippmann and Friedrich Winkler, *Zeichnungen von Albrecht Dürer*, Berlin, 1929, Band VII, p. 21, cat. and pl. 844.
Eduard Flechsig, *Albrecht Dürer. Sein Leben und seine künstlerische Entwicklung*, Berlin, 1931, vol. II, pp. 468/9.
Hans Tietze and Erica Tietze-Conrat, *Kritisches Verzeichnis der Werke Albrecht Dürers*, Basle, 1938, vol. II, p. 18, no. 789, repr. p. 158.
Friedrich Winkler, *Die Zeichnungen Albrecht Dürers*, Berlin, 1939, vol. 4, p. 28, no. 797.
Erwin Panofsky, *Albrecht Dürer*, Princeton, 1945, vol. II, p. 67, no. 560.
Edmund Schilling, *Albrecht Dürer Zeichnungen und Aquarelle*, Basle, 1948, p. 22, repr. pl. 43, p. 69.
Walter L. Strauss, *The Complete Drawings of Albrecht Dürer*, New York, 1974, vol. 4, p. 1980 repr.

£300,000 $550,500 DM1,151,250 (lot 20) Karlsruhe Kunsthalle

HANS BURGKMAIR

THE ENCOUNTER BETWEEN VALENTIN AND OURSSON IN THE FOREST OF ORLEANS

Pen and black ink. Inscribed on the old mount by a later hand in ink: *Roland le Furieux*.

$8\frac{1}{4}$in. \times $11\frac{3}{16}$in. 21cm. \times 28.5cm.

Valentin was sent by his uncle King Pepin, into the forest of Orleans to apprehend the wild man who had plagued travellers. The drawing depicts their struggle, in which Valentin was the victor. He led the wild man back to Paris where he was baptised Oursson. Later an interview with the magical Brazen Head in the Castle of the Lady Clerimond, reveals that Valentin and Oursson were twin brothers, the sons of Empress Bellisant and Alexander of Greece. Oursson had been lost as an infant and brought up in the forest of Orleans by a bear. A German translation of the Carolingian story *Valentin and Orson* was first published at Basle in 1521, the date of printing being 14 February 1521 (W. Seelman, *Valentin und Namelos*, Niederdeutsche Denkmäler, IV, Norden and Leipzig, 1884). Although German translations were current in manuscript before this date, it is likely that Burgkmair, who died in 1523, derived his knowledge of the story from the printed book. The drawing may therefore be dated to 1521–3.

PROVENANCE:
Eugène Rodrigues, his sale, Amsterdam, Müller, 12–13 July, 1921, lot 15, pl. XI.

EXHIBITED:
Augsburg, Staatliche Gemäldegalerie, *Burgkmair Ausstellung*, 1931, no. 35 (on an inserted leaflet printed by the Museum and headed *Zeichnungen von Hans Burgkmair*).

LITERATURE:
Société de Reproductions des Dessins de Maîtres, second series, 1910.
Hans Rupe, *Beiträge zum Werke Hans Burgkmairs des älteren*, 1912, p. 16.
K. T.Parker, *Weiteres über Hans Burgkmair als Zeichner* in *Beiträge zur Geschichte der Deutschen Kunst, Augsburger Kunst der Spätgotik und Renaissance*, 1928, p. 220, no. 17.
Arthur Burkhard, *Hans Burgkmair der Ältere*, 1935, p. 39, no. 17.
Peter Halm, *Hans Burgkmair als Zeichner*, Münchner Jahrbuch der bildenden Kunst, 1962, p. 118–9, illus. fig. 51 (suggests dating soon after 1500).
Tilman Falk, *Hans Burgkmair, Studien zu Leben und Werk des Augsburger Malers*, 1968, pp. 26, 38, 44.

£80,000 $146,800 DM307,000 (lot 23)

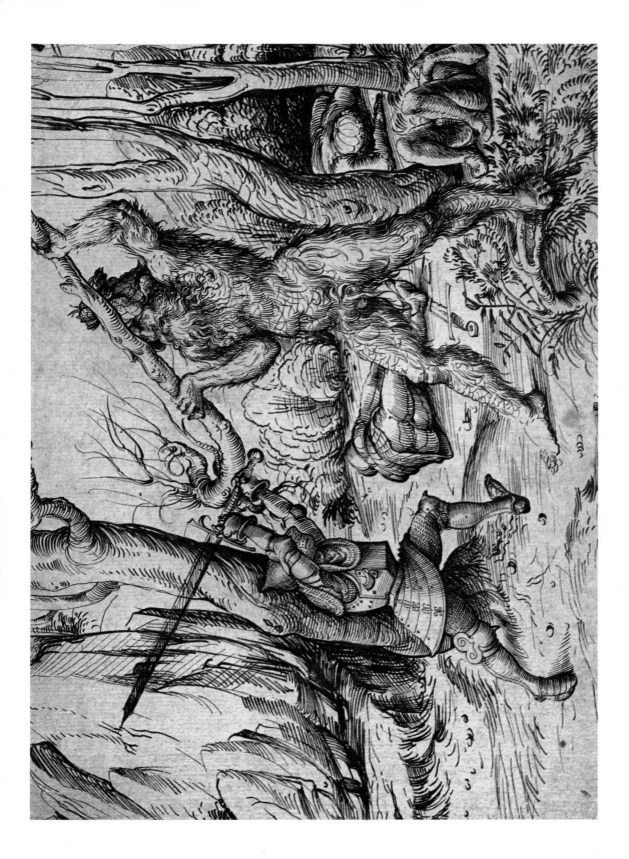

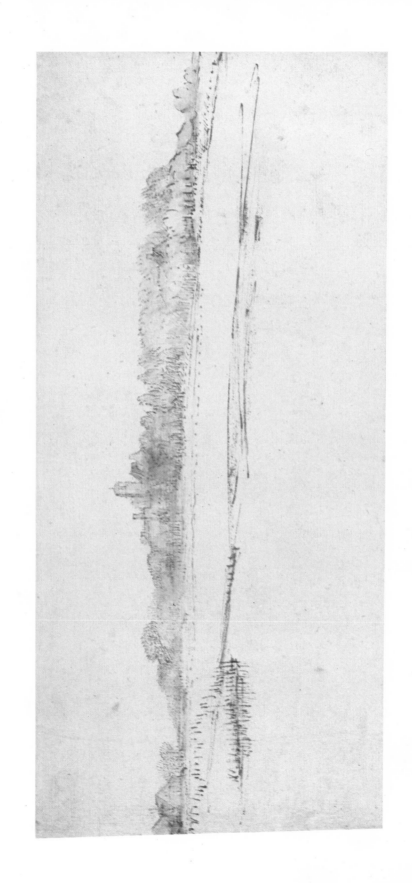

REMBRANDT HARMENSZ. VAN RIJN

LANDSCAPE WITH THE "HUYS MET HET TOORENTJE" (*House with the Little Tower*)

Pen and brown ink and wash.

$8\frac{7}{16}$in. $\times 3\frac{13}{16}$in. 9.7cm. \times 21.4cm.

Dated by Benesch about 1651–2 as it closely approaches in style the etching dated 1651, *The Goldweigher's Field* (Hollstein B234). The view, first recognised by Hind (1932–3), shows the house which once belonged to the Receiver General, Jan Uytenbogaert. It is situated beside the road running along the river Schinckel from Amsterdam to Amstelveen which was one of Rembrandt's favourite excursions outside Amsterdam. This same house, though seen from a different viewpoint, appears in the background of the etching *Landscape with Trees, Farm Buildings and a Tower*, (Hollstein B223) also datable ca. 1651.

Benesch writes "The immense subtlety of the drawing is due to the effect of the technique of dotting, in which Rembrandt followed the model of Pieter Bruegel's landscape drawings. A few washes suffice to suggest the humidity of the atmosphere."

PROVENANCE:
Paul Jodot (Paris 1907). Otto Gutekunst.

EXHIBITED:
London, Royal Academy, *Dutch Art 1450–1900*, 1929, no. 624; *Commemorative Catalogue of the Exhibition of Dutch Art*, Royal Academy, Burlington House, London, 1930, p. 210.
Amsterdam, Rijksmuseum, *Rembrandt Tentoonstelling*, 1932, no. 282.
London, Royal Academy, *17th Century Art in Europe*, 1938, no. 564.
Basle, Katz-Galerie, *Rembrandt-Ausstellung*, 1948, no. 33.
Paris, Orangerie des Tuileries, *Le Paysage Hollandais au XVII Siècle*, 1950–1, p. 63, no. 154 bis.
Amsterdam, Rijksmuseum/Rotterdam, Boymans Museum, *Rembrandt*, 1956, no. 162.

LITERATURE:
Vasari Society for the Reproduction of Drawings by Old Masters, Second Series, Part V, 1924, no. 10.
A. M. Hind, *British Museum Quarterly*, VII, no. 3, 1932–3, p. 63.
Otto Benesch, *Rembrandt, Selected Drawings*, London, 1947, vol. I, p. 37, no. 177, vol. II, pl. 177 reproduced.
J. G. van Gelder, *Review of Benesch 1947, op. cit., Burlington Magazine*, July, 1949, p. 206ff.
Ludwig Münz, *A Critical Catalogue of Rembrandt's Etchings*, London, 1952, vol. II, p. 85 under no. 168.
J. Q. van Regteren Altena, *Het Landschap van den "Goudweger"*, Oud Holland, 1954, vol. LXIX, pp. 1–17.
Otto Benesch, *The Drawings of Rembrandt*, London, 1957, vol. VI, no. 1267, fig. 1564; 2nd edition 1973, vol. VI, no. 1267, fig. 1564.
E. Haverkamp Begemann, *Review of Benesch 1957, op. cit., Kunstchronik*, XIV, 1961, p. 27.
Otto Benesch, *Rembrandt as a Draughtsman*, London, 1960, p. 155, no. 67.
Christopher White, *Rembrandt as an Etcher*, London, 1969, p. 212.
Christopher White and Karel G. Boon, *Hollstein's Dutch and Flemish Etchings, Engravings and Woodcuts*, Amsterdam, 1969, p. 108, under no. 223.

£154,000 $282,590 DM590,975 (lot 35)

REMBRANDT HARMENSZ. VAN RIJN

SHAH JAHAN

Pen and dark brown ink and wash on Japanese paper washed pale brown. Inscribed in brown ink by Sir Gore Ouseley on the back of Richardson's mount: *Portrait of Sháh Jehán Emperor of Hindustan* ‏شاہ جہان پادشاہ‎ and by another hand in pencil: *written by Sir Gore Ouseley.*

8⅞in. × 6¾in. 22.5cm. × 17.1cm.

One of twenty-one copies by Rembrandt of Indian Miniatures of the Mogul school all dated by Benesch in the period of 1654–56. They were copied by him from an album of Dutch provenance, whose leaves were later broken up for the decoration of an 18th century room in Schloss Schönbrunn, Vienna. The influence of these studies can be traced very frequently in figures used in Biblical and historical drawings of 1655/56, *ie. The Good Samaritan*, Berlin (Benesch 945); *King David*, Berlin (Benesch 947) and New York, Metropolitan (Benesch 948); *Manoah*, Paris, Institut Néerlandais (Benesch 980), etc. Benesch sums up his entry "Rembrandt's copies after the Indian works are admirable proofs of the master's ability to enter the spirit of those exotic works of art. It is remarkable that he approached in the specific delicacy of their line work strongly the style of the great Persian draughtsman Riza-Abasi, also a contemporary of Rembrandt, although we have no evidence that he ever saw any of his works".

Shah Jahan was the fifth of the great Mogul Emperors of India. He ruled from 1627 until 1658 when he was deposed and imprisoned by his son Aurangzeb. During his reign the Empire achieved its most glorious courtly period. Today, he is best known for his contributions to the architectural heritage of India exemplified by the Taj Mahal, the great monument to his wife Mumtaz Muhal. He died in 1666, it is said of a broken heart.

PROVENANCE:
Jonathan Richardson Snr. (L.2184), his sale, Cock, London, 22 Jan., 1747, p. 40, lot 70, from "a book of Indian Drawings, 25 in number", (nineteen are at present recorded).
Lord Brownlow, Belton House, his sale, Sotheby's, 29 June, 1926, lot 25 bt. Duveen.
W. R. Valentiner, his sale, Mensing, Amsterdam, 25 Oct., 1932, lot XII, reproduced.

LITERATURE:
Wilhelm R. Valentiner, *Rembrandt Handzeichnungen, Klassiker der Kunst*, Stuttgart [n.d.], p. 223, no. 643.
Otto Benesch, *Rembrandt, Werk und Forschung*, Wien, 1935, p. 56.
Otto Benesch, *Rembrandt's Selected Drawings*, London, 1947, vol. I, p. 44, no. 229, vol. II, pl. 229, reproduced.
Otto Benesch, *The Drawings of Rembrandt*, London, 1957, vol. V, no. 1193, fig. 1417; 2nd edition 1973, vol. V, no. 1193, fig. 1491.
Kenneth Clark, *Rembrandt and the Italian Renaissance*, London, 1966, pp. 166–7, reproduced.

£160,000 $293,600 DM614,000 (lot 38) Cleveland Museum of Art

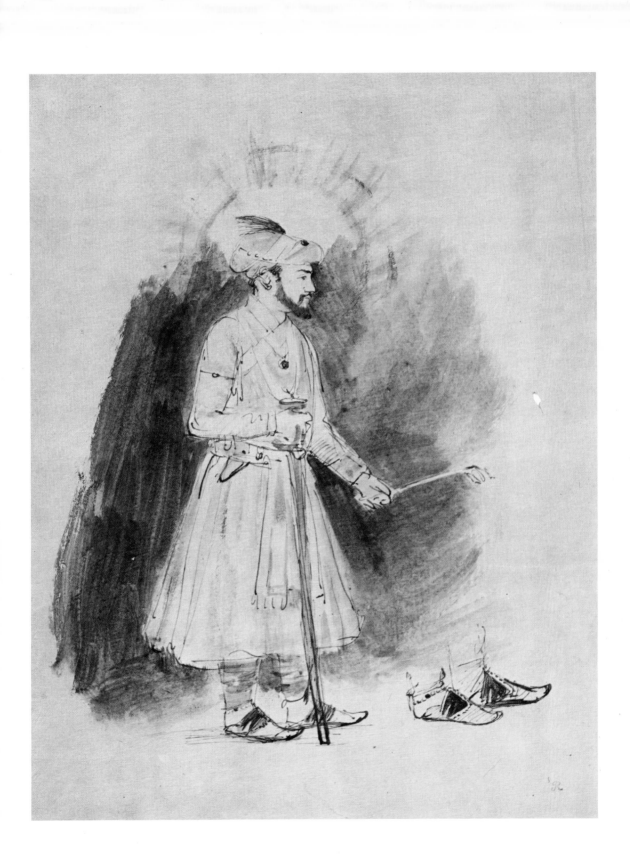

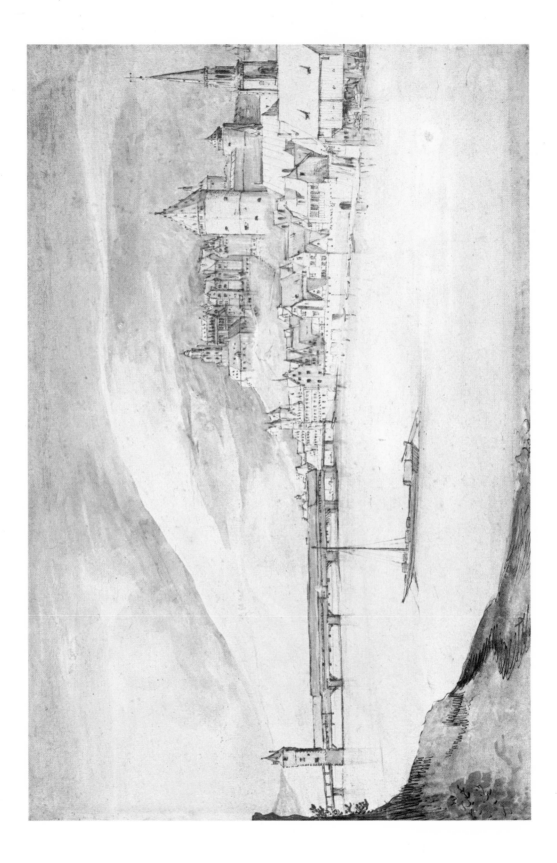

JAN BRUEGHEL THE ELDER

VIEW OF HEIDELBERG

Pen and brown ink and blue and brown wash. Inscribed in pencil by a later hand:
P. Brugel. With a watermark similar to Briquet 10569 (Brussels *circa* 1588).

$7\frac{7}{8}$in. \times $11\frac{15}{16}$in. 19.9cm. \times 30.4cm.

Swarzenski and Schilling point out that this study can be dated before 1601 as the
building of the Friedrich house has not yet begun. They suggest that it must have
been executed by Brueghel either on his way to, or from, Italy, i.e. 1593 or 1597.
The companion to this drawing, *The Bridge of Heidelberg*, was reproduced in the
sale catalogue of Jacob Klein, Frankfurt Kunstverein, 7 Dec., 1910, lot. 14.

EXHIBITED:
Frankfurt, Städelsches Kunstinstitut, *Handzeichnungen alter Meister...*, 1924,
no. 33.

LITERATURE:
Georg Swarzenski and Edmund Schilling, *Handzeichnungen alter Meister aus
Deutschem Privatbesitz*, Frankfurt, 1924, p. xv, no. 33 reproduced.
Philipp Witkop, *Heidelberg und die deutsche Dichtung*, Leipzig 1925, pl. 1, facing
p. 16.
Ludwig Münz, *The Drawings of Brueghel*, London 1961, p.235, no. A35, pl. 186
reproduced.

£58,000 $106,430 DM222,575 (lot 29)

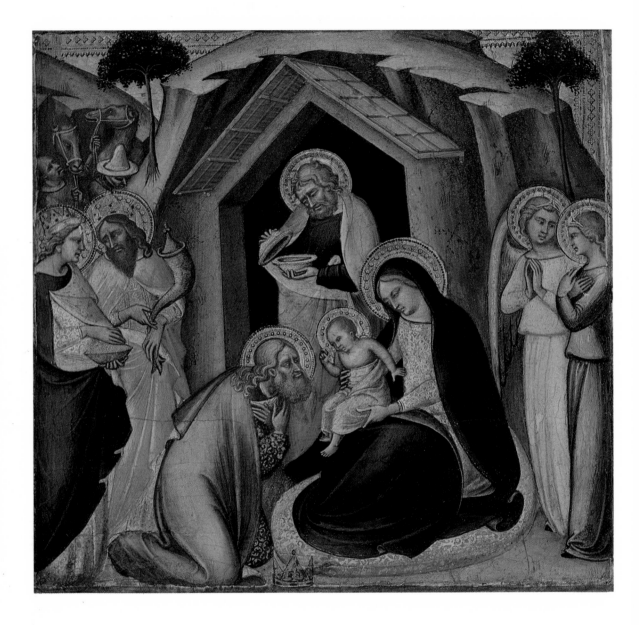

LUCA DI TOMMÈ

THE ADORATION OF THE MAGI

The Virgin, dressed in a blue cloak over a gold and pink gown, seated on a large golden pillow, supporting the Infant Christ who raises his right hand to bless the kneeling King before him; St. Joseph behind, at the entrance of a shelter hewn out of a large rock, holding a gold cup and cover, two more Kings dressed in orange and blue to the left, holding gifts, grooms tending camels behind; two angels to the right dressed in yellow and pale blue; *gold ground with a punched border*.

On panel.

16⅜in. × 16½in. 41.25cm. × 42cm.

Recognised by Meiss, *op. cit.*, as a companion to a *Crucifixion* in the M. H. de Young Memorial Museum, San Francisco (no. 61.44.3, Kress Collection, no. K.34) which is dated by Shapley, *op. cit.*, about 1366.

PROVENANCE:
Maitland F. Griggs, New York (according to Berenson, *op. cit.*, 1930 and 1931);
In the collection of Robert von Hirsch by January, 1927.

LITERATURE:
F. Mason Perkins in U. Thieme and F. Becker, *Allgemeines Lexikon der Bildenden Künstler*, vol. XXIII, 1929, p. 427;
B. Berenson, *Quadri senza Casa: Il Trecento Senese-I* in *Dedalo*, 1930–1, vol. II, p. 274;
B. Berenson, *Missing Pictures of the Sienese Trecento-Part II* in *International Studio*, November, 1931, p. 27;
B. Berenson, *Italian Pictures of the Renaissance*, 1932, p. 312;
B. Berenson, *Pitture Italiane del Rinascimento*, 1936, p. 268;
M. Meiss, *Notes on three linked Sienese styles* in *The Art Bulletin*, March, 1963, p. 48 (reproduced fig. 9);
F. R. Shapley, *Paintings from the Samuel H. Kress Collection: Italian Schools XIII–XV Century*, 1966, p. 59;
B. Berenson, *Italian Pictures of the Renaissance: The Central and North Italian Schools*, 1968, vol. I, p. 224.

£75,000 $138,015 DM287,250 (lot 102)
The Thyssen-Bornemisza Collection, Lugano, Switzerland

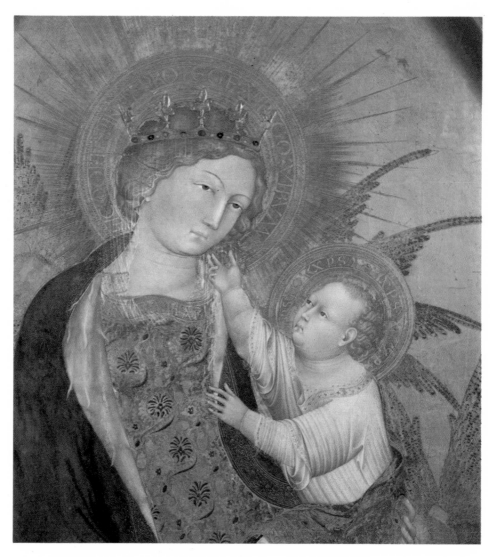

(Detail: for illustration of complete subject see frontispiece)

GIOVANNI DI PAOLO

THE BRANCHINI MADONNA

The Virgin, seated full length, turned to the right, her halo inscribed, *HC:QUI:TE(:)PINSIT(:)PROTEGE:VIRGO:VIRUM(:)()*, her gesso crown, inlaid with coloured stones, supporting a small veil, her hair held in a golden band, wearing a magnificent gown decorated with oak-leaves and acorns in punched gold and blue and gold flowers on a rose ground, inscribed at the neck, *AVEAMARI(.)*, and at her right wrist, *(.)MGO*, and over it and falling in folds around her a blue ermine-lined cloak, its border decorated with a design in gold and (formerly) stones; with her left knee and her two hands she supports the standing Christ Child, who reaches out with both arms towards her, his halo inscribed, *(.)S:XPS:XPS:XPS*, and wearing a white gown and undershirt each with a decorated border, and a rich yellow and gold drapery decorated with pomegranate leaves and fruit in punched gold and gold, blue and grey cardoons, its lining having a pattern in blue, green and red; the two figures framed and supported by the red heads and multiple red and blue wings of seraphim; in the gable, the Dove and, above, Christ, half length in benediction, supported by seraphim; below, white roses, cornflowers, and marigolds; *gold ground*.

Signed on the base of the frame, *·JOHANNES·SENENSIS·PAULI·FILIUS· PINXIT·M·CCCC·XXVII:*

On panel, arched top.

Size overall, $71\frac{3}{4}$in. × $36\frac{3}{4}$in. 182cm. × 93.5cm.

The frame is original in the base and the gable, and partially made up on each side. This is the centre panel of a polyptych painted for the chapel of the Branchini family in the church of San Domenico, Siena; the other panels, four standing saints including St. Christopher, to whom the altar was dedicated, and the predella are lost. A photograph of the altarpiece taken in the early part of this century shows the Virgin and Christ each holding a rosary and the painting is listed as a *Madonna del Rosario* in descriptions of the Chigi-Saracini collection made at this time. It seems probable that the added rosaries were removed during a restoration made in Italy *circa* 1920, for they do not appear in a photograph of the altarpiece taken in the studio of Prof. Wilhelm Horst, Darmstadt in 1923, when the blue of the Virgin's robe was repainted.

The altarpiece was moved to the refectory of the Convent of San Domenico when the Branchini Chapel was destroyed (Urgurgieri, *loc. cit.*) The panel was purchased by the Saracini family and placed in the chapel of their villa at Castelnuovo Berardenga. On the destruction of this chapel in the 19th century the panel was moved to the Palazzo Saracini in Siena (Salmi, *loc. cit.*).

(continued on next page)

PROVENANCE:
Church of San Domenico, Siena;
Convent of San Domenico, Siena by 1649;
Willa Saracini, Castelnuovo Berardenga;
Palazzo Chigi-Saracini, Siena, inventory no. 1263;
Purchased by Robert von Hirsch from the Saracini family *circa* 1922.

Pope-Hennessy, *op. cit.*, refers to the tradition that Gentile da Fabriano employed Giovanni di Paolo as an assistant during his visits to Siena in 1425 and 1426 when he painted the *Madonna dei Notai*, now lost. He suggests that the considerable stylistic development between Giovanni di Paolo's Pecci Madonna of 1426 and the Hirsch panel may be explained by this period of collaboration, and that the Branchini Madonna may be in part based on the *Madonna dei Notai*.

Oak leaves and acorns are an attribute of the Virgin, pomegranates symbolize her chastity and cardoons the Passion of Christ. The marigold, as its name suggests, is dedicated to the Virgin and the white rose is applied both to the Immaculate Conception and to the joyous mysteries of the rosary. The cornflower is associated with Christ, through a legend, and, because of its colour, with Heaven.

EXHIBITED:
Frankfurt am Main, Städelsches Kunstinstitut, *Ausstellung von Meisterwerken alter Malerei aus Privatbesitz*, 1925, no. 84.
The 1926 catalogue of the Frankfurt exhibition (see below) states that the panel appeared in the *Mostra dell'Antica Arte Senese*, Siena, 1904, but it is not recorded in the general catalogue of the exhibition or in C. Ricci, *Il Palazzo Pubblico di Siena e la Mostra d'Antica Arte Senese*, 1904.

LITERATURE:
Monsignore Egidio Bossio, *Visita Pastorale*, 1575, ms. Curia Arcivescovile, Siena, p. 680 (cited by Pope-Hennessy, *op. cit.*);
Sigismondo Tizio, *Historiarum Senensium*, ms. Bibl. Com. Siena, vol. iii, p. 9 & vol. iv, p. 207 (cited by Pope-Hennessy, *op. cit.*);
I. Ugurgieri Azzolini, *Le Pompe Sanesi*, 1649, vol. ii, p. 346;
Ettore Romagnoli, *Bellartisti Senesi*, ms. Bibl. Com. Siena, vol. ii, p. 4, vol. iv, pp. 314 & 328,9 (cited by Pope-Hennessy, *op. cit.*);
W. Heywood and L. Olcott, *Guide to Siena*, 1903, p. 224 (1924 ed., p. 253);
E. Jacobsen, *Das Quattrocento in Siena*, 1908, p. 42 (reproduced pl. XIII, fig. I);
B. Berenson, *The Central Italian Painters of the Renaissance*, 1909, pp. 180 & 320;
J. A. Crowe and G. B. Cavalcaselle, *A History of Painting in Italy*, edited by T. Borenius, 1914, vol. v, p. 178;

C. H. Weigelt in U. Thieme and F. Becker, *Allgemeines Lexikon der Bildenden Künstler*, vol. XIV, 1921, p. 134;

Dedalo, August, 1925, pp. 201 & 202 (reproduced).

O. Götz, G. Swarzenski and A. Wolters, *Ausstellung von Meisterwerken alter Malerei aus Privatbesitz . . . MCMXXV*, 1926, no. 80 (reproduced pl. XIII);

R. van Marle, *The Development of the Italian Schools of Painting*, 1927, vol. IX, pp. 334, 390 & 394 (reproduced fig. 251);

B. Berenson, *Italian Pictures of the Renaissance*, 1932, p. 246;

G. H. Edgell, *A History of Sienese Painting*, 1932, p. 215 (reproduced fig. 300);

B. Berenson, *Pitture Italiane del Rinascimento*, 1936, p. 211;

J. Pope-Hennessy, *Giovanni di Paolo*, 1937, pp. 9, 10 & 46 (reproduced pl. IB);

E. Carli, *Capolavori dell'Arte Senese*, 1946, p. 66;

C. Brandi, *Giovanni di Paolo*, 1947, p. 10 (reproduced fig. 15);

C. Brandi, *Quattrocentisti Senesi*, 1949, pp. 258 & 286 (reproduced pl. 124);

E. Carli, *La Pittura Senese*, 1955, p. 222;

M. Salmi, *Il Palazzo e la Collezione Chigi-Saracini*, 1967, pp. 40, 45 & 50;

B. Berenson, *Italian Painters of the Renaissance: The Central Italian and North Italian Schools*, 1968, pp. 175 & 463.

£500,000 $920,100 DM1,915,000 (lot 103) The Norton Simon Foundation

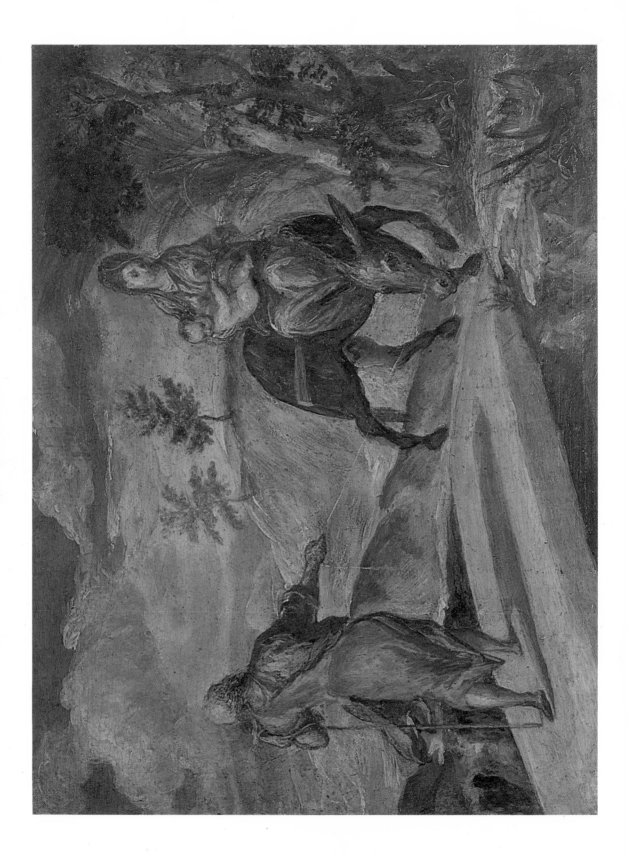

DOMENIKOS THEOTOCOPULI known as EL GRECO

THE FLIGHT INTO EGYPT

In a mountain landscape the Virgin, in red with a blue cloak, holding the Child, is seated on an ass which Joseph, in a yellow cloak lined with blue, is trying to pull with a rope across a little bridge over a stream.

On panel. $6\frac{1}{4}$in. \times $8\frac{1}{2}$in. 15.8cm. \times 21.5cm.

The back of the panel bears the brand of Don Gaspar Méndez de Haro (*DGH* in monogram surmounted by a coronet). The same brand is on a number of other pictures from the same collection: *e.g.* El Greco's *Espolio* in the Bearsted collection and *Christ at Gethsemane* ascribed to Lo Spagna in the National Gallery, London. Accepted generally as an early work of El Greco after his arrival in Italy. It is dated *circa* 1570 by Waterhouse, 1572–5 by Mayer and by Wethey *circa* 1565–70.

PROVENANCE:
Possibly in the collection of Luis Méndez de Haro y Guzmán, 2nd Conde – Duque de Olivares (died 1675);
Certainly in the collection of his son, Gaspar Méndez de Haro, Marqués de Heliche y del Carpio, Spanish Ambassador in Rome and Viceroy of Naples. It appears in the list of his pictures shipped from Naples to Spain in 1686, now in the Escorial archives, under no. 933 as by Bassano: the number 933 is painted on the back of the panel;
After his death in 1687 it presumably passed to his daughter, Catalina Méndez de Haro, who married in 1688 the 10th Duke of Alba;
In the collection of the Dukes of Alba, probably until the beginning of the 19th century;
Antonio Gorostiza, Bilbao (by 1904) until *circa* 1926;
Mrs. Marie Sterner, New York, sold to Agnew, 1929;
Bought by Robert von Hirsch from Agnew in the same year.

EXHIBITED:
Bilbao, *Exposición de Pintura Retrospectiva*, 1904, No. 81;
Bordeaux, Musée des Beaux-Arts, *Domenico Theotocopuli dit le Greco*, 1953, no. 11 (reproduced pl. VIII).

LITERATURE:
M. B. Cossío, *El Greco*, 1908, p. 555, no. 31 (as very doubtful);
A. L. Mayer, *Dominico Theotocopuli, El Greco*, 1926, p. 7, no. 24 (reproduced pl. I);
E. K. Waterhouse in *Art Studies*, 1930, p. 73 (reproduced fig. 10);
H. Vollmer in U. Thieme and F. Becker, *Allgemeines Lexicon* etc., vol. XXXIII, 1939, p. 5;
Reproduced in M. Legendre and M. Hartmann, *El Greco*, 1937, p. 129;
M. Gómez-Moreno, *El Greco*, 1943, p. 48 (reproduced p. 49);
J. Camón Aznar, *Dominico Greco*, 1950, vol. I, p. 59 (reproduced fig. 37) and vol. II, pp. 1359–60, no. 68;
M. S. Soria in *Arte Veneta*, 1954, p. 220, no. 47;
J. A. Gaya Nuño, *La Pintura Española fuera de España*, 1958, p. 86, no. 1190;
H. E. Wethey, *El Greco and his School*, 1962, vol. I, p. 21, and vol. II, pp. 56–7, no. 83 (reproduced fig. 2);
E. Arslan in *Commentari*, vol. XV, 1964, p. 216;
J. Gudiol, *El Greco*, English ed. 1973, pp. 28 (no. 12) and 29 (reproduced figs. 18–20).

£90,000 $165,618 DM344,700 (lot 115)

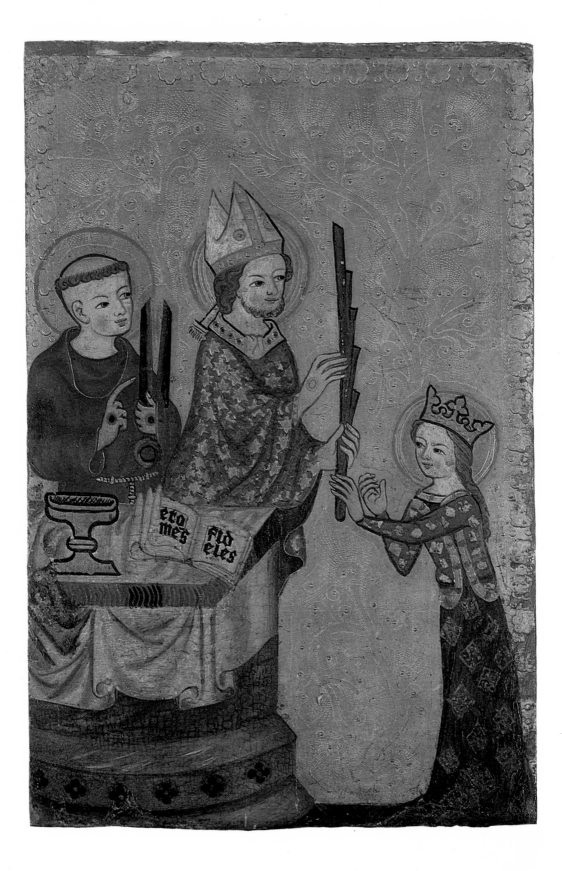

SCHOOL OF NUREMBERG, THIRD QUARTER OF 14th CENTURY

THE BISHOP OF ASSISI HANDING A PALM TO SAINT CLARE

The Bishop, wearing a gold and deep red chasuble, hands a palm to the young St. Clare who stands before him, crowned, and wearing a red and gold tunic over a green and red gown; behind the Bishop, St. Francis who points to a pair of shears he holds in his left hand; before them a stone altar, covered with a white cloth, on which stand a gold chalice and a book inscribed *eto/m[n]es/fid/eles*. *Gold ground punched with a vegetal motif within a geometric border.*

On panel.

13¼in. × 8⅝in. 33.5cm × 22cm.

The panel illustrates the events of Palm Sunday, 1212, when the Bishop of Assisi singled out the young St. Clare to receive a palm. This symbolic act, probably arranged by St. Francis, proved decisive in encouraging the girl to abandon her life as a daughter of a wealthy nobleman. Within a few hours her hair had been shorn, her rich garments thrown off and St. Francis had received her into the Order.

Part of an altarpiece consisting of several small panels depicting scenes from the life of St. Clare, probably painted for the *Clara-Kloster* in Nuremberg. Companion panels are in the Germanisches Nationalmuseum, Nuremberg, nos. 1217, 1161 & 1187, in the Historisches Museum, Bamberg, nos. 38 & 39 and a fragment formerly in a private collection in Regensburg.

PROVENANCE:
In the collection of Robert von Hirsch by 1931.

Most authorities date the altarpiece *circa* 1360–70 and Stange, *op. cit.*, has suggested that the studio responsible may have been in the *Clara-Kloster* itself, as panels from another altarpiece painted in the same studio are known which also depict scenes from the life of St. Clare. For a stylistic discussion of the work of this studio, without specific reference to the Hirsch painting, see B. Kurth, *Die Wiener Tafelmalerei in der ersten Hälfte des 14. Jahrhunderts und ihre Ausstrahlungen nach Franken und Bayern* in *Jahrbuch der Kunsthistorischen Sammlungen in Wien*, 1929, pp. 45 *et seq.*

EXHIBITED:
Nuremberg, Germanisches Museum, *Nürnberger Malerei, 1350–1450*, June–August, 1931, no. 33f. (as by the Master of the High Altar of the Jakobskirche, Nuremberg).

LITERATURE:
E. H. Zimmerman and E. Lutze, *Nürnberger Malerei, 1350–1450, Anzeiger des Germanischen Nationalmuseums*, 1932, pp. 10, 24, 25 & 50 (reproduced pl. 35).
A. Stange, *Deutsche Malerei der Gotik*, 1933 reprinted 1969, vol. 1, p. 201 (reproduced pl. 210).
Catalogue of the exhibition, *Des Maîtres de Cologne à Albert Dürer*, Paris, Musée de L'Orangerie, 1950, p. 32.

£55,000 $101,211 DM210,650 (lot 117)

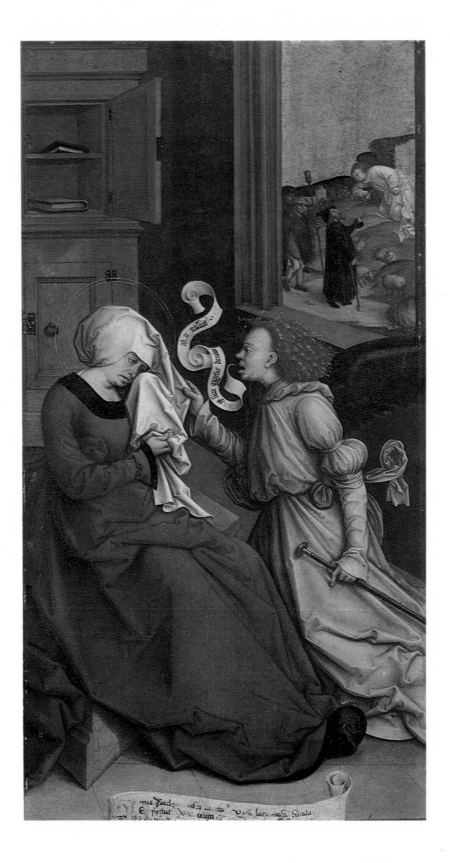

BERNHARD STRIGEL

THE ANNUNCIATION TO SAINT ANNE AND SAINT JOACHIM

The interior of a room built of stone; in the foreground St. Anne weeping, seated on a bench, wearing a deep red gown and white wimple with which she dries her tears assisted by an angel wearing a pale yellow robe who stands before her, a scroll issuing from his mouth inscribed, *Ego sum angelus domini ad te missus*; behind her, a cupboard with one door open revealing books on shelves, to the right a window with a landscape beyond and St. Joachim, to whom an angel in a pink robe appears, and shepherds with their animals, a sky of punched gold above; below, a scroll, inscribed: *Anna Joach [ino] iusto evecta; Prece lacrimosa furata | E [x]pectat dona cel (..) : U(..) confusionem: | Ambo capiunt foramen: Et (.....).*

On panel.

23in. × 11¾in. 58cm × 30cm.

The subject is taken from Jacopo de Voragine, *The Golden Legend*, chap. 131.

Otto, *op. cit.*, rejects earlier attempts to connect the Hirsch panel with the Schussenried altarpiece, whose style and quality it resembles closely, and compares its iconography with that of a series of paintings made by Strigel and his studio on the wall of the tower of the Frauenkirche, Memmingen. She dates the panel ca. 1506–07. Stange, *op. cit.*, *1970*, suggests that a pair of panels representing *The Holy Family with Angels* and *The Infant St. John the Baptist* in the Kunsthistorisches Museum, Vienna, (nos. 1430a & b) may be connected with the Hirsch panel although they are from a different hand.

PROVENANCE
R. Traumann, Madrid, 1912;
In the collection of Robert von Hirsch by 1925.

EXHIBITED
Frankfurt am Main, Städelsches Kunstinstitut, *Ausstellung von Meisterwerken alter Malerei aus Privatbesitz*, 1925, no. 228.

LITERATURE:
A. L. Mayer, *Madrider Privatsammlungen II, Die Gemälde der Sammlung R. Traumann* in *Cicerone*, 1912, p. 97 (reproduced fig. 7);
O. Götz, G. Swarzenski, and A. Wolters, *Ausstellung von Meisterwerken alter Malerei aus Privatbesitz . . . MCMXXV*, 1926, no. 200 (reproduced pl. XLVI);
A. Stange, *Deutsche Malerei der Gotik*, 1933, reprinted 1969, vol. VIII, p. 143 (wrongly described as an *Annunciation to the Virgin*);
J. Baum in U. Thieme and F. Becker, *Allgemeines Lexikon der Bildenden Künstler*, vol. XXXII, 1938, p. 188;
G. Otto, *Bernhard Strigel*, 1964, pp. 30 & 95, cat. no. 18 (reproduced pl. 61);
A. Stange, *Kritisches Verzeichnis der deutschen Tafelbilder vor Dürer*, 1970, vol. II, p. 203, no. 985a.

£120,000 $220,824 DM459,600 (lot 118)
The Thyssen-Bornemisza Collection, Lugano, Switzerland

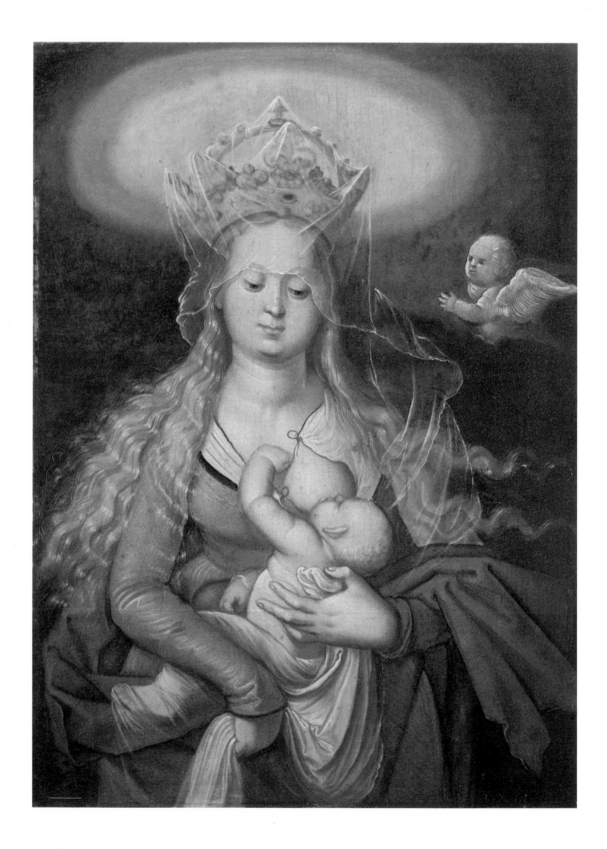

HANS BALDUNG called GRIEN

THE VIRGIN AS QUEEN OF HEAVEN

The Virgin, rather more than half length, a circle of light about her head, wearing a large crown covered by a transparent veil, her fair hair falling about her shoulders, dressed in a crimson robe, nursing the Infant Christ who lies in her arms; to the right a cherub amid clouds on a blue ground.

On panel.

14in. × 10in. 33.5cm. × 25.5cm.

All authors agree that this panel dates from Baldung's Freiburg period; Koch, *op. cit.*, suggests a date *circa* 1514, von der Osten (in a letter of 1978) follows Curjel, *op. cit.*, in preferring 1516, or a little later.

PROVENANCE:
Private collection, Basel, 1907.
The Hohenzollern Collection, Sigmaringen, until 1928.
Purchased by Robert von Hirsch, 1928.

EXHIBITED:
Frankfurt am Main, *Sigmaringer Sammlungen*, 1928, no. 31.

LITERATURE:
M. J. Friedländer in U. Thieme and F. Becker, *Allgemeines Lexikon der Bildenden Künstler*, vol. II, 1908, p. 404;
H. Curjel, *Hans Baldung Grien*, 1923, pp. 75 & 151 (reproduced pl. 45);
F. Rieffel, *Das fürstlich Hohenzollernsche Museum zu Sigmaringen, Gemälde und Bildwerke* in *Städel-Jahrbuch*, 1924, vols. 3–4, p. 61 (reproduced pl. XIXa);
A. L. Mayer, *Die fürstlich Hohenzollern'schen Sammlungen in Sigmaringen; I. Die Gemälde . . .*, in *Pantheon*, 1928, vol. I, p. 62;
C. Koch, *Katalog der erhaltenen Gemälde, . . . von Hans Baldung Grien* in *Kunstchronik*, November, 1953, p. 298;
To be published by Professor G. von der Osten in his forthcoming monograph on Hans Baldung Grien.

£245,000 $450,849 DM938,350 (lot 119)

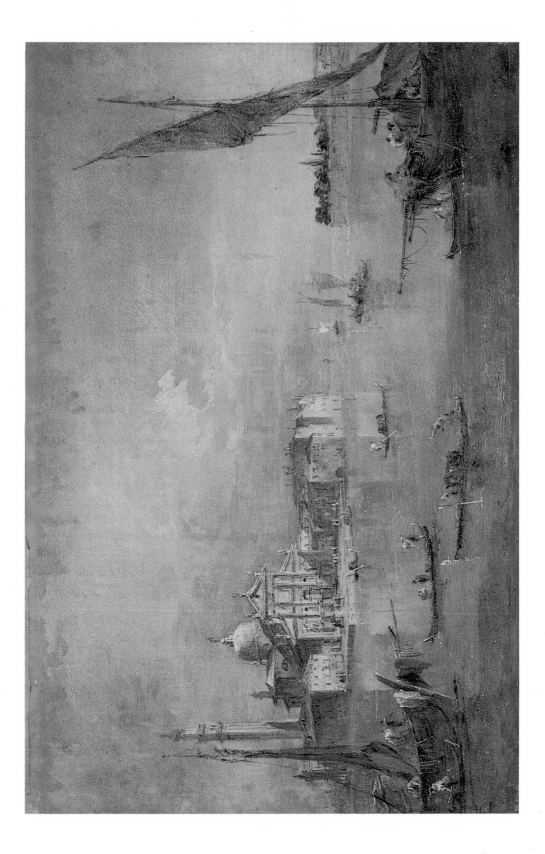

FRANCESCO GUARDI

VENICE: SAN GIORGIO MAGGIORE

The island and church of San Giorgio Maggiore and, to the right, the extreme end of the Giudecca; in the foreground gondolas and, on either side, a small sailing-vessel.

Possibly on paper laid on panel.

8¼in. × 13in. 21cm. × 33cm.

Professor Antonio Morassi considers this a late work.

PROVENANCE:
Fritz von Gans, Frankfurt.

EXHIBITED:
Frankfurt am Main, Städelsches Kunstinstitut, *Ausstellung von Meisterwerken alter Malerei aus Privatbesitz*, 1925, no. 99;
Paris, Trotti Gallery, 1932.

LITERATURE:
O. Götz, G. Swarzenski and A. Wolters, *Ausstellung Meisterwerken alter Malerei aus Privatbesitz . . . MCMXXXV*, 1926, no. 96 (reproduced pl. XC);
A. Morassi, *Guardi*, (1973), vol. I, no. 446.

£60,000 $110,412 DM229,800 (lot 113)

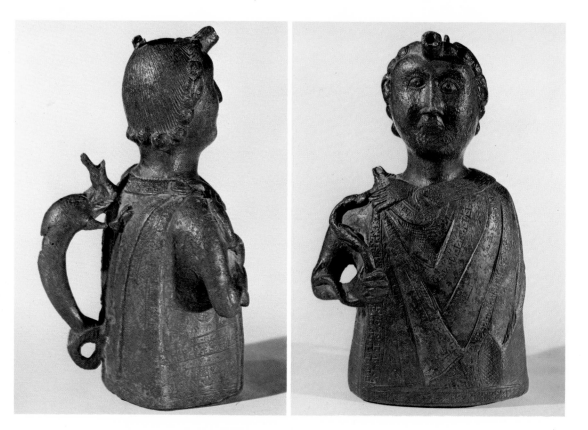

A LOWER SAXON BRONZE AQUAMANILE

Formed as the bust of a youth, his hair ending in tight curls, clothed in an antique cloak (paludamentum) with parallel folds and richly embroidered borders held by a brooch on his right shoulder, a snake in his right hand biting his left which emerges from his cloak on his right shoulder, spout on forehead, filling aperture in top of head, the handle a dragon with open mouth, the hinged cover and plug from base missing.

10in. high (26cm.) *Early 13th Century, Hildesheim or Magdeburg*

Described by Falke and Meyer as an important key-piece, related to the earlier Bacchus bust in the treasury of Aachen Cathedral from the Liège-Aachen area. However, the circles enclosing cross-hatching, which are standard features of the decoration of the aquamaniles in the form of knights and centaurs, justify attribution to the Hildesheim or Magdeburg workshop. Both workshops exported to the eastern parts of Europe

PROVENANCE:
Excavated in the Baltic area.
A. Seligmann, Paris

LITERATURE:
Falke and Meyer, p. 53, no. 332, fig. 309 a, b.
V. P. Darkevic, 'Proizvedenija zapadnogo chudozestvennogo remesla v vostocnoj europe (X-XIV vv.)', *Archeologija* SSSR, 1966, pl. 89

£62,000 $114,669 DM237,925 (lot 206)

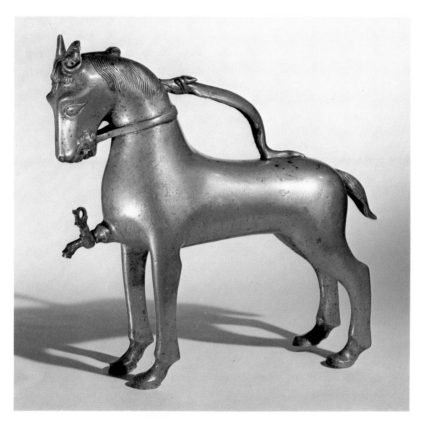

A NORTH GERMAN BRONZE AQUAMANILE

In the form of a bronze horse with spout in chest, hinged opening in the top of his head, chiselled mane and tail, bridle, the handle a dragon biting the horse's neck, numerous core pin plugs; the tap and spout restored.

11¾in. high (30cm.) *Circa 1400, North Saxony*

PROVENANCE:
Fürst Hohenzollern, Sigmaringen

EXHIBITION:
Frankfurt am Main, 1928, no. 605

LITERATURE:
Falke and Meyer, p. 88, no. 578, fig. 531

£45,000 $83,227 DM172,687 (lot 207)

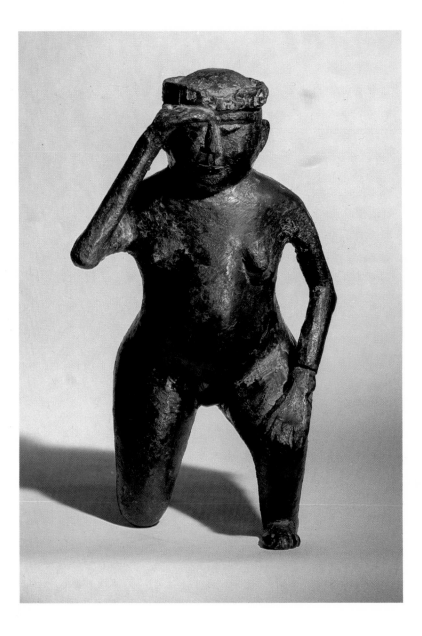

A NORTH ITALIAN BRONZE FIGURE OF A NAKED WOMAN

Kneeling on her right leg, her left hand resting on her left knee, her right arm lifted to shade her eye, signed on a circlet round her forehead: STEF N S LAGER P: ME FECIT; long hair incised down her back, circular opening, perhaps for extracting the core in back, the female member filed away later, left wrist fractured, left buttock dented and pierced.

12⅝in. high (32cm.) *Circa* 1100

The inscription was expanded by Boeckler as *Stefanus Lagerensis Pictor*, i.e. made by Stephen, sculptor, of the Valle Lagarina (in the South Tirolean Etschtal between Verona and Bozen). The closest parallel to this figure is found in the bronze doors of the church of San Zeno in Verona, particularly the relief panel, allegorical of the land, with Eve pulling the plough. These evidently come from the same or a closely related workshop, and it was the discovery of this figure in 1929 that finally established the local source of these San Zeno bronzes and others in similar style. The kneeling pose implies that the figure was either a single support for a candlestick or one of three or four for a baptismal font or large Paschal candlestick. The balance of the figure suggests the latter probability, in which case the hole in the back may have served for attachment. In arriving at the pose, the sculptor has conformed to the model of the aeolopile (fire-blower or Püstrich) of the period, a comparable but later one being preserved in Schloss Sondershausen and another 12th century one in Vienna. The absence of a hole in the lips excludes such a purpose unless for some reason the piece remained unfinished

PROVENANCE:
Purchased by Cassirer of Rome in the Veneto

LITERATURE:
Falke and Meyer, p. 34, no. 250, figs. 214 a, b.
A. Boeckler, *Die Bronzetür von Verona*, Marburg a. Lahn, 1931, p. 37, pl. 3.
W. L. Hildburgh, 'Aeolopiles as Fire-Blowers', *Archaeologia*, Vol. XCIV, Oxford, 1951, pl. xiiid.
P. Bloch, 'Der siebenarmige Leuchter in Klosterneuburg', *Jahrbuch des Stiftes.*
Klosterneuburg, N.F., Bd. 2, 1962, p. 171, fig. 18.
Vienna, Kunsthistorisches Museum, *Katalog Sammlung Plastik und Kunstgewerbe* I, 1964, p. 45/6

£100,000 $184,950 DM383,750 (lot 208)

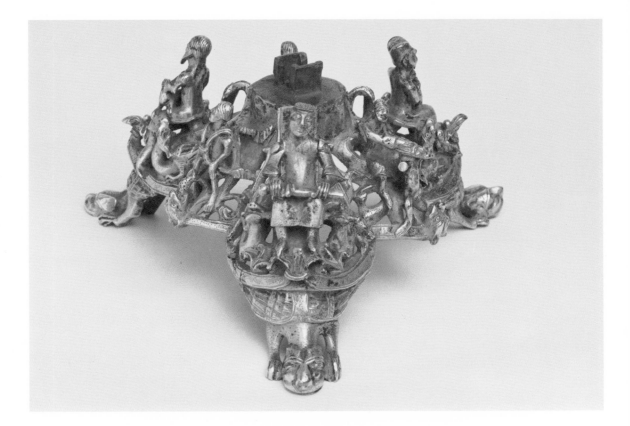

A LARGE ENGLISH GILT ALTAR CANDLESTICK OR CROSS FOOT BASE

Triangular, the feet formed as winged dragons, each with a figure modelled in the round seated on its back on a staff held by two other dragons: (1) a knight in long coat (of mail?) with both hands resting on his sheathed sword, (2) a man wearing a cap and long coat with embroidered borders, a falcon on his left wrist, (3) a bearded man with dog on his lap. The triangular spaces between these figures filled with the convoluted bodies of three dragons, centering on three male figures modelled in the round, (4) a nude youth entrapped in scrolls and holding a fruit for which a dragon contends, (5) a man holds the hair of a man with his right hand and cuts his throat with a knife, (6) a man extracts a thorn from his foot, presumably derived from the antique; at the top of the base two upright members for the attachment of a stem.

4in. high, maximum width 8in. (10cm. by 20.5cm.) *Early 12th Century*

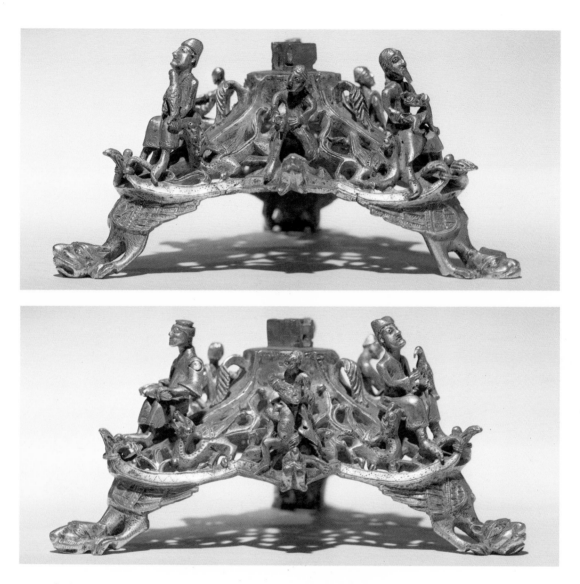

Of the three celebrated surviving bronze Romanesque candlesticks, the example associated with Gloucester in the Victoria and Albert Museum, the Milan Cathedral example and the one preserved in Rheims Museum, this foot is most closely related in execution to the first, which was given to the Abbey (now Cathedral) of St. Peter, Gloucester, between 1104 and 1113

PROVENANCE:
Basilewski, Paris.
Hermitage Museum, Leningrad.

LITERATURE:
A. Darcel and A. Basilewski, *Collection Basilewski*, Paris, 1874, cat. no. 128.
Falke and Meyer, p. 16, no. 91, fig. 89 a, b, c.
Swarzenski, *Monuments*, fig. 211

£550,000 $1,017,225 DM2,110,625 (lot 210)

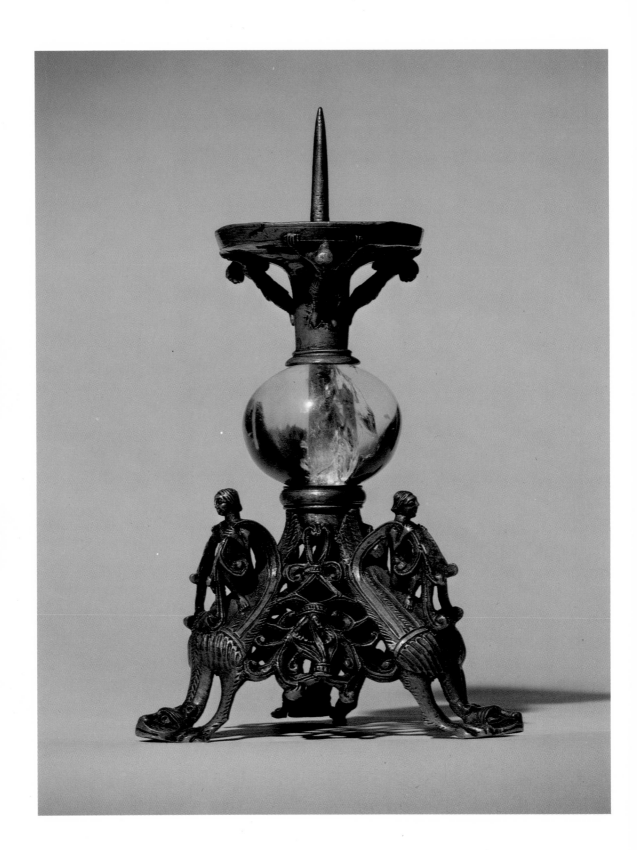

A LARGE GERMAN BRONZE ALTAR CANDLESTICK

The triangular base composed of three winged dragons whose heads and claws form the feet, on the back of each is perched a man, between openwork foliate scrolls; the knop a large rock crystal sphere pierced for the stem, which terminates above in a circular drip pan supported by three male figures in short tunics attached on brackets; the iron stem, pricket, and bronze ring between base and knop later.

10⅝in. high (27cm.) *12th Century, Rhenish, probably Cologne*

Another Rhenish candlestick with angels instead of men perched on dragons on the base in the Focke Museum, Bremen, is illustrated Falke and Meyer, fig. 86, but the treatment of the figures with scrolls passing over their shoulders on the present candlestick appears to derive from the similar arrangement of the figures on the base of the Gloucester Candlestick

PROVENANCE:
A church in Lodz, Poland.
J. Paul, Hamburg, Sale, Cologne 1882.
R. von Passavant-Gontard, Frankfurt am Main, 1929, no. 109, pl. 37.
Pannwitz, Bennebroek

LITERATURE:
Falke and Meyer, p. 16, no. 89, fig. 87

£170,000 $314,415 DM652,375 (lot 213) Kestner-museum, Hannover

ONE OF THE PAIR OF ENAMEL ARMILLAE (ARM ORNAMENTS) PROBABLY FROM THE CORONATION VESTMENT OF THE EMPEROR FREDERICK I BARBAROSSA

Decorated in champlevé technique with the Crucifixion in brilliant colours on gilt copper ground, the faces and the details of anatomy executed in black enamel; the figure of Christ on a blue cross, flanked by Longinus with his spear and Stephaton with sponge and bucket, behind him the Virgin Mary and St. John, two half figures of angels above, the three soldiers in mail shirts casting lots for Christ's vesture below; the gilt ground pricked with a pointed instrument on each side of Christ.

Mosan or Rhenish, attributed to Godefroid de Claire (Falke) or to a Mosan enameller in whose workshop Nicholas of Verdun was trained (Lasko)

$4\frac{1}{2}$in. by 5in. by $1\frac{3}{4}$in. (11.5cm. by 13cm. by 4.5cm.) *Circa* 1165

This armilla, together with the companion piece depicting the Resurrection acquired by the Louvre in 1935, is thought by some authorities to have formed part of the Imperial regalia of Frederick Barbarossa and to have been presented by him to the Russian Prince Andrew Boguloubski (1111–74), whose embassy visited the Imperial Court at Aachen in 1165. It was later given to the Cathedral of Vladimir on the river Kljasma, north east of Moscow, and remained in Russia until the present century. One other pair of late 12th century imperial armillae survived as part of the Treasure of the Holy Roman Emperors in Nuremberg until the French invasion in 1796 but were lost after 1800. They were seen by J. A. Delsenbach in Nuremberg and his engravings published in 1790 survive in the Nuremberg Stadtbibliothek. They represent the birth of Christ and the Presentation in the Temple

Various dates between 1160 and 1180 have been suggested for these armillae, the earlier being suggested by the marked Byzantine influence and the recorded visit of the embassy of Prince Boguloubski to Aachen in 1165. Bühler (*Das Münster*, p. 408) suggests that the Emperor may have sent them as a present to Russia as they were old-fashioned but, if so, they must have been replaced by the similar pair which survived until 1796. An alternative suggestion by Bühler is that the second pair was worn by the Empress

The sainted Russian Grand Prince Andrew Bogoloubski, son of Grand Prince Yuri Dolgoruki, was responsible for sacking the city of Kiev in 1169, an event which led directly to a transfer of power from Kiev to his new capital at Vladimir. Symbolic of this transfer was his removal from the Kievan treasury at Vyshgorod of the celebrated 12th century Byzantine icon of the Mother of God, which he gave to his new Cathedral of the Dormition at Vladimir. According to the Russian Primary Chronicle and certain other early sources, the architects and craftsmen employed by him at Vladimir came not only from Georgia and Armenia, but also from Western Europe

(continued on page 66)

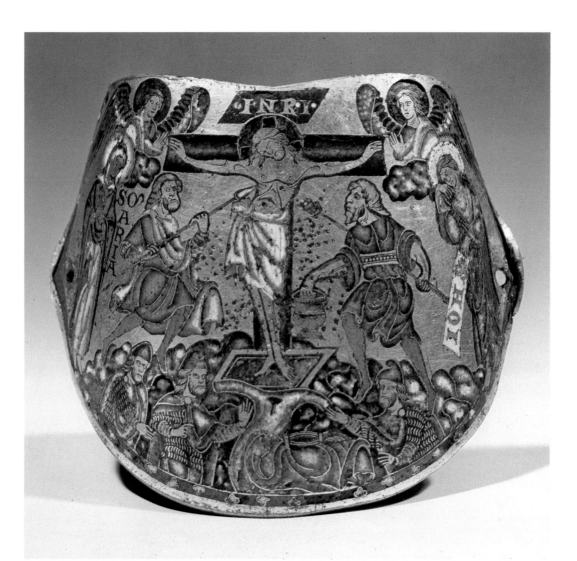

(actual size)

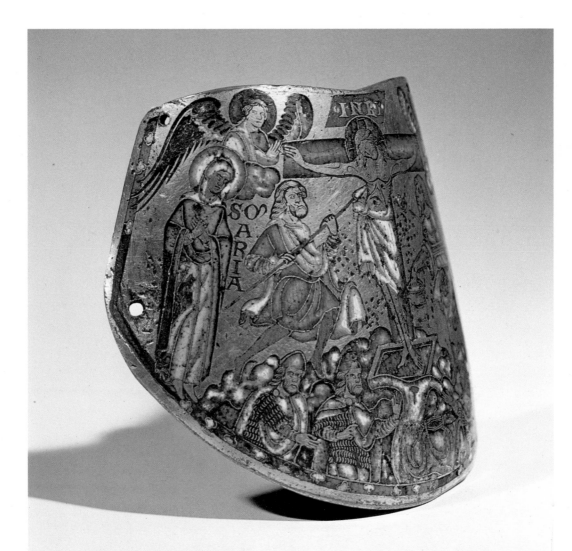

(*continued*)

PROVENANCE:
Cathedral of Vladimir, near Moscow, from the last quarter of the 12th century until after 1903.
Museum Bonmiantzeff, Moscow 1911.
Botkin, St. Petersburg till 1917.
Hermitage Museum, Leningrad, 1917 till 1933

LITERATURE:
Baron de Baye, 'Emaux de la Cathédrale de Vladimir et du Couvent de Saint-Antoine-le-Romain (Russie)', *Mémoires de la Société nationale des Antiquaires de France*, 62, 1903, pp. 19–24.
Collection M. P. Botkine, St. Petersburg, 1911, no. 94.

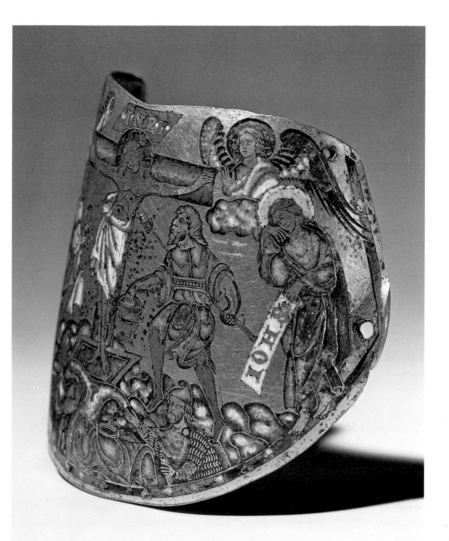

C. Dreyfus. 'Une plaque d'émail mosane au musée du Louvre', *Monuments et Mémoires (Fondation Piot)*, 35, 1935–36, pp. 176–8, fig. 3.

O. Homburger, 'Autour de Nicolas de Verdun', *L'Art Mosan*, 1953, pp. 191–192.

H. Swarzenski, Art Bulletin, 24, 1942, p. 301.

H. Swarzenski, *Monuments of Romanesque Art*, 1954, no. 72.

P. E. Schramm, *Herrschaftszeichen und Staatsymbolik*, 1954–56, pp. 547–550.

P. E. Schramm, F. Mütherich, *Denkmäle der deutschen Könige und Kaiser*, 1962, no. 175.

V. P. Darkevic, 'Proizvedenija zapadnogo chudozestvennogo remesla v vostocnoj europe (X-XIV vv.)', *Archeologija* SSSR, 1966, no. 42, p. 117, fig. 4.

M. M. Gauthier, *Emaux du moyen âge occidental*, 1972, no. 119.

P. Lasko, *Ars Sacra 800–1200*, 1972, 217ff.

A. Bühler, 'Zur Geschichte der deutschen Reichskleinodien', *Das Münster*, December 1974, 408–409.

Die Zeit der Staufer: Geschichte-Kunst-Kultur, Stuttgart, 1977, no. 541, pp. 401–404, fig. 331. The present armilla, although not included in the exhibition, is however illustrated in the catalogue, fig. 332 and there dated 1175–80

£1,100,000 $2,034,450 DM4,221,250 (lot 222)
Germanisches Nationalmuseum, Nürnberg

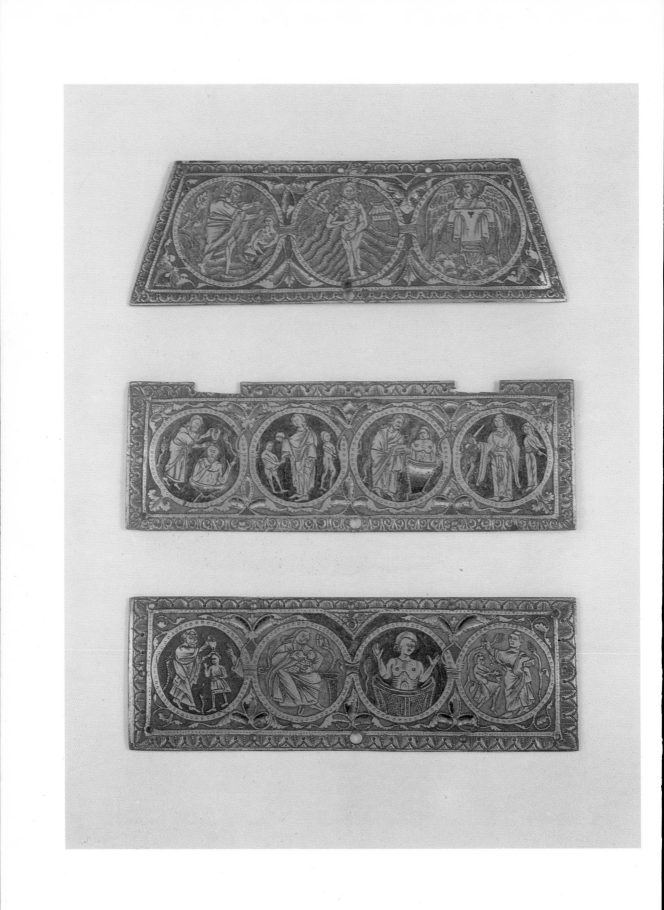

A SET OF THREE ENGLISH TRANSLUCENT AND OPAQUE CHAMPLEVE ENAMEL PLAQUES FROM A CASKET

Perhaps for a chrismatory, each with chased gilt foliate border.

1. Front panel, four medallions with figures against grounds enamelled alternately blue and green, the spandrels with gilt foliage against blue and white or green, red and white ground, the figure details engraved and filled with reddish brown enamel.
 a) Anointment, a priest laying his left hand on the head of a boy and pouring oil from a bottle held in his right, to the right the hand of God appears.
 b) A young woman seated suckling an infant.
 c) Baptism, a nude young man seated in a tub, his hands raised.
 d) A monk with tonsure and book blessing a youth standing by his side.

2. Rear panel, the border cut at the top for the hinges, four medallions, enamelled alternately green and blue.
 a) Baptism, perhaps of Saul by Ananias (Acts, Chapter IX, v. 11) an old man baptising another half immersed in water.
 b) A woman standing holding out a veil flanked by two nude youths, making a gesture of shame.
 c) A nude man standing in a tub, receiving instruction from an Apostle (?) holding a book.
 d) A standing woman in long robe holding a candle accompanied by a handmaiden.

3. Front panel from lid, three medallions with green and blue grounds.
 a) St. John the Baptist standing, arms outstretched towards the figure of Christ in the central medallion, at his side a naked figure holding an urn from which flow the waters of Jordan.
 b) Christ standing nude with the waters of Jordan behind Him, His hand covering His body, to His left a house, the dove of the Holy Ghost engraved in the border above.
 c) An angel with wings extended holding ready the tunic of Christ.

$6\frac{1}{2}in.$ by $2\frac{1}{4}in.$ (16.5cm. by 5.9cm.) *Late 12th Century*

A casket attributed to the same workshop in the Bargello, Florence, formerly Carrand Collection, is illustrated Swarzenski, *Monuments* fig. 490. Also related is the small casket with figures of Grammar, Rhetoric and Music in the Victoria and Albert Museum, illustrated Lasko, fig. 280

PROVENANCE:
A. M. Silver, Monks Risborough, Buckinghamshire, Sotheby's, 8th May, 1935, lot 128

LITERATURE:
Swarzenski, *Monuments*, pl. 209, fig. 491

£260,000 $480,870 DM997,750 (lot 225)

A LOWER SAXON CHEST-SHAPED RELIQUARY CASKET OF WOOD

Veneered on all sides with two exotic Eastern woods and on the cover, the base of walnut, the lining of beech, with ivory or bone borders and standing on gilt copper feet, the corners held by copper straps terminating in open 'C' shaped ovals and the hinge straps of similar form, iron lock on the base; on the cover between the hinge strap ends, a rectangular Cologne champlevé enamel plaque with the gilt half figure of St. Matthew holding a ribbon inscribed VENIET DIES CV AUFERTVR, the inner lines of figure and lettering filled with dark blue enamel, the ground blue with green and shaded blue and white outer borders, pearled edges, the evangelist with yellow and white halo, his name in gilt letters; some ivory border strips wanting, lock inoperative, enamel chipped at borders.

8¼in. long, 3⅓ high, 3½in. deep (21cm., 8.5cm., 9cm.), Circa 1150/70
the enamel 3¼in. by 2¼in. (8cm. by 5.5cm.)

Described in the 1482 inventory of the Guelph Treasure: *Schrinium antiquum ligneum quod eciam solet stare superius in altari et exponi in festibus dominicalibus superius habens ymagines* (sic) *sancti mathei*

228 (*detail*)

The Guelph Treasure is the name customarily given to the collection of one hundred and forty precious objects donated between the 11th and 15th century to the cathedral of St. Blaise in Brunswick by the rulers of Brunswick. The residue of the Treasure, comprising some eighty-two pieces, was sold by Duke Ernst August of Brunswick-Lüneberg to a commercial syndicate in 1930. In 1935, the Prussian Government, acting on behalf of the Berlin Schlossmuseum (now Kunstgewerbemuseum), purchased forty-two pieces from the Treasure from the syndicate, the remainder having previously been disposed of on the international market, principally to museums and collectors in the United States

Similar caskets are preserved in the Cathedral treasuries of Halberstadt, Quedlinburg, Gandersheim and the Diozesanmuseum, Paderborn

PROVENANCE:
Guelph Treasure, Brunswick

EXHIBITION:
Berlin and Frankfurt am Main, 1930, no. 19

LITERATURE:
W. A. Neumann, *Der Reliquienschatz des Hauses Braunschweig-Lüneburg*, 1891, no. 25.
Falke, Schmidt und Swarzenski, *Der Welfenschatz*, Frankfurt 1930, no. 19, p. 130.
G. Swarzenski 'Aus dem Kunstkreise Heinrichs des Löwen', *Städel Jahrbuch* 1932, p. 343, n. 289.
E. Steingräber, 'Email', *Reallexikon zur deutschen Kunstgeschichte*, V, 1967, p. 31

£150,000 $277,425 DM575,625 (lot 228)
Herzog Anton Ulrich-museum, Braunschweig

THE MOSAN ENAMEL MEDALLION ATTRIBUTED TO GODEFROID DE CLAIRE OF THE ANGEL REPRESENTING OPERATIO (CHARITY) FROM THE SPANDRELS OF THE STAVELOT RETABLE

The winged half figure with halo, enamelled in blue, green and white, the former shading into light blue and yellow, holding an orb in his left hand, a white cap on his head, within a palmette border enamelled in the same colours, the whole against a gilt ground, outer border pierced, punched and gilt, repeating the pattern of the inner one. This enamel is preserved in pristine condition.

$5\frac{3}{4}in.$ *diameter* (14.5*cm.*) *Circa* 1150

This medallion, the companion in the Museum für Kunsthandwerk, Frankfurt am Main, and two strips with inscriptions are all that remain of the silver gilt and champlevé enamel shrine and retable ordered by Abbot Wibald of Stavelot (1130–1158) in honour of St. Remaclus, the founder of the Abbey, the remainder having been melted down either before 1661 or in the last years of the 18th century. A drawing in the Archives de l'Etat, Liège, dated 1661, shows the original form of the retable, with the medallions on either side of the dove of the Holy Ghost in the spandrels over the central arch

It is known that Abbot Wibald employed a goldsmith whose name began with the letter 'G' in the years before 1148 and this goldsmith is traditionally identified as a certain Godefroid of Huy (or de Claire) who was regarded, in the following century, as the most accomplished master of his craft. Unfortunately, it is not certain that Godefroid was actually employed on the Stavelot Retable, nor has anything survived which can unreservedly be attributed to him

PROVENANCE:
David Fischbach, Louvain, about 1860, allegedly directly from Stavelot.
Fürst Hohenzollern, Sigmaringen, inv. no. 1593

EXHIBITION:
Frankfurt am Main, 1928, no. 294

LITERATURE:
Lehner, *Emailwerke*, no. 42

(*continued on page 74*)

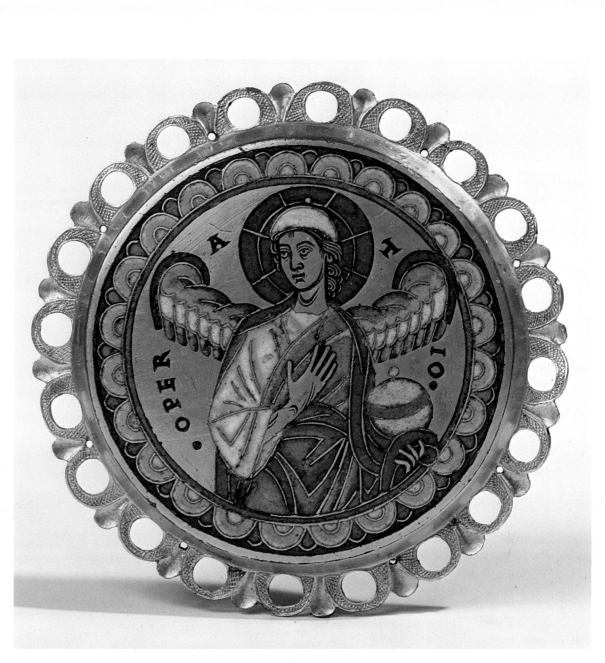

(actual size)

(*continued*)

Falke and Frauberger, *Deutsche Schmelzarbeiten des Mittelalters*, Frankfurt am Main, 1904, p. 74ff, p. 86ff.

J. de Borchgrave d'Altena, J. Yernaux, 'L'église abbatiale de Stavelot', *Bulletin de la Société d'Art et d'Histoire du diocèse de Liège*, 24, 1932, p. 145ff.

K. H. Usener, 'Sur le chef-reliquaire du Pape Saint Alexandre', *Bulletin des Musées Royaux d'Art et d'Histoire*, 6, 1934, p. 59.

S. Collon-Gevaert, *Histoire des arts du métal en Belgique*, 1951, pp. 158–177.

H. Swarzenski, *Monuments of Romanesque Art*, 1954, p. 68, no. 366.

J. Deer, 'Die Siegel Kaiser Friedrichs I. Barbarossa und Heinrichs VI. in der Kunst und Politik ihrer Zeit', *Festschrift Hahnloser*, 1961, p. 47ff.

F. Ronig, 'Godefridus von Huy in Verdun', *Aachener Kunstblätter* 32, 1966, pp. 83–91.

Rhein und Maas: Kunst und Kultur 800–1200, Cologne, 1972, G10.

M. M. Gauthier, *Emaux du Moyen Age occidental*, 1972, no. 83, p. 345ff.

P. Lasko, *Ars Sacra 800–1200*, 1972, p. 185ff.

Die Zeit der Staufer: Geschichte-Kunst-Kultur, Stuttgart, 1977, no. 453, p. 456–8.
The present medallion although not included in the exhibition was illustrated on the back cover of Vol. I and fig. 335 in colour

£1,200,000 $2,219,400 DM4,605,000 (lot 231)
Kunstgewerbemuseum, Berlin

(actual size)

AN UPPER RHINE CHAMPLEVE ENAMEL AND GILT COPPER MEDALLION OF THE VISITATION

The figures of Mary and Elizabeth embracing, the inner drawing of their forms filled with red or black opaque enamel, within a diaper of gilt rosettes against a brilliant ruby red ground, the border with gilt quatrefoils against a dark green ground between iron red bands, four fixing perforations on the edge.

2½in. diameter (6.2cm.) *Early 14th Century*

PROVENANCE:
Victor Gay Collection, Paris.
Stora, Paris, before 1936

LITERATURE:
Victor Gay, *Glossaire archéologique du Moyen Age*, I, 1887, p. 623.
E. Steingräber, 'Email', *Reallexikon zur deutschen Kunst geschichte*, V, 1967, fig. 35.
M.-M. Gauthier, *Emaux du moyen age occidental*, p. 268, no. 217.
H. J. Heuser, *Oberrheinische Goldschmiedekunst im Hochmittelalter*, 1974, p. 164, no. 63, fig. 401

£130,000 $240,435 DM498,875 (lot 234)
Wurttembergisches Landesmuseum, Stüttgart

A LIMOGES ENAMEL EUCHARISTIC DOVE FROM THE MARIENSTIFT OF ERFURT (THURINGIA)

The head, body and legs engraved with imbrications to represent plumage, the wings, tail and circular base enamelled blue, red, white and green in shaded colours, the wings fixed, hinged cover to receptacle in body; enamel chipped on wings and base, the enamel eyes wanting.

$7\frac{1}{2}$*in. high,* $4\frac{1}{2}$*in. wide* (19*cm.,* 11.4*cm.*) *Circa* 1200

Madame M.-M. Gauthier has established the identity of this dove with that formerly in the Erfurt monastery and illustrated in an 18th century water-colour drawing by M. de Belmont, prepared on the instructions of the Elector Lothar Franz von Schönborn, archbishop of Mainz, for the antiquary Dom Bernard de Montfaucon and now preserved in the Bibliothèque Nationale, Paris, *Manuscrit Latin* 11907, fol. 107

Dom Montfaucon was the author of *L'Antiquité expliquée et représentée en figures*, published 1719

PROVENANCE:
Marienstift, Erfurt.
Fürst Hohenzollern, Sigmaringen, inv. no. 5116

EXHIBITION:
Frankfurt am Main, 1928, no. 295

LITERATURE:
Hefner-Alteneck, *Kunstkammer*, pl. 23.
Lehner, *Emailwerke*, no. 62.
M.-M. Gauthier 'Colombe limousine prise aux rets d'un antiquaire benedictin à Saint Germain des Près vers 1726' *Intuition und Kunstwissenschaft: Festschrift für Hanns Swarzenski*, Berlin 1973, pp. 171ff., fig. 11

£100,000 $184,950 DM383,750 (lot 239)

A VENETIAN ENAMELLED BLUE-GLASS GOBLET AND COVER

The bowl of bell shape supported on a hollow ribbed mushroom knop above a domed and ribbed conical foot with an upward fold, the knop and foot gilt between the ribs, the bowl decorated with a wide central band of scale pattern, each scale with a pale-blue enamel dot, the whole between narrow green-dotted bands enclosing rosettes in black and white with red centres, a widely-spaced white dot line border at the base of the bowl and below the rim, the domed and ribbed cover gilt to match the foot and terminating in a bell knop with *cristallo* finial.

12¾*in.* (*32.5cm.*) *Circa* 1500

A number of blue-glass goblets of this shape are recorded; perhaps the closest is one with another variety of scale pattern in the Musée Curtius, Liège, illustrated in Mariacher, *Vetri del Rinascimento*, Milan 1963, p. 47

PROVENANCE:
The Spitzer Collection, 1891, Catalogue Vol. III, no. 1978, illustrated in colour, pl. V
The Baron von Rothschild Collection, Grüneburg

£50,000 $92,475 DM191,875 (lot 257)

A VENETIAN ENAMELLED BEAKER

Probably made for the marriage of Michael Behaim and Katerina Lochnerin of Nuremberg in 1495; of almost barrel shape tapering towards the base above an applied foot rim decorated in brilliant enamel colours with three cusped panels outlined in 'lattimo', one containing the arms and crest of Behaim (*per pale gules and argent, a bend wavy sinister, the crest a falcon proper ducally engorged*) in white, black and reddish brown, the other with the standing figure of St. Michael slaying Lucifer with his sword, and the third with St. Catherine and the head of the Emperor Maximinius, divided by three flowering trees and reserved on a ground with a continuous greensward picked out in black and white, the rim and base with borders of blue and red dots on gilt scales and lappets.

4⅝in. (11.5cm.) *Circa* 1495

The arms have recently been identified as those of Behaim, a family of Bohemian origin. A branch of this family settled in Nuremberg where it is recorded that Michael Behaim married Katerina Lochnerin in 1495. The use of figures of saints to indicate the names of the betrothed is most unusual. The normal decoration on such 'coppe nuziale' consists of the armorial bearings of each party, the so-called *allianzwappen*; see, for example, the Imhof/Stark goblet of *circa* 1530 and the Praun beakers of *circa* 1589 in the British Museum.

This beaker seems to be one of the two earliest known surviving examples of Venetian Glass made for export. One formerly in Breslau had the arms of Hungary and Bohemia as borne by Mathias Corvinus who died in 1490; but the arms might also be the arms of his successor Wlaidislau II Jagelion (died 1516). The next firmly dated glass was that made in 1511 for Jörg Kopidlnansky von Kopidlna

See Robert Schmidt's article, 'Die Venezianischen Emailgläser des XV und XVI Jahrhunderts', *Jahrbuch der k. Preussischen Kunstammlungen*, Berlin, 1911, pp. 276–278; the same author's *Das Glas*, 1912, pp. 94–95: 1922, pp. 96–97; Axel von Saldern, *German Enameled Glass*, New York, 1965, pp. 33–37; and R. J. Charleston, *Glass and Enamels: the James A. de Rothschild Collection at Waddesdon Manor*, 1977, pp. 16–17 for a discussion of dateable armorial glasses

For examples with similar 'greensward' decoration see the Bargello goblet illustrated in Mariacher, *Italian Blown Glass*, pl. 27; the green goblet in the British Museum, see *Masterpieces of Glass*, 1968, pl. 207, and the 'Fairfax Cup' sold in these rooms 10th March, 1959, lot 123

For the shape see Robert Schmidt, *Das Glas*, figs. 54 and 56, both beakers formerly in the Berlin Kunstgewerbe Museum, now destroyed

£55,000 $101,722 DM211,062 (lot 258)

THE CELEBRATED HAFNER-WARE PORTRAIT POT (KRAUSE)

Of hard-fired earthenware and of bag shape, the upper part missing, modelled in coloured relief on a sand-strewn ground with three bust portraits of Ferdinand I, King of Hungary (1503–64), of his wife Anne of Hungary (1503–47), and probably of the former's brother, the Emperor Charles V (1519–56), in light brown, black, blue and white on a blue ground, on the underside a cream-coloured rosette from which springs three green acanthus leaves.

4in. high, 3⅝in. diameter (10cm., 9cm.) *Circa* 1530

This pot and a similar one formerly in the Figdor Collection, but lacking the portrait of Anne of Hungary, belong to a small group of vessels with sand-strewn decoration discussed by Alfred Walcher-Molthein in an article 'Hafnergeschirre der Renaissance', *Belvedere Forum*, Jan–July 1925, pp. 71–9. While Nuremberg is a probable centre of production, an Austrian origin is not excluded. As potters, the names Oswald Reinhart, Preuning and Hirschvogel have all been suggested

Similar portraits of members of the Habsburg family can be seen on stove tiles in Danzig and Cracow

Related in subject matter is the blue glass beaker, dated 1529, of Venetian or South German origin, formerly in the Sigmaringen Collection, now in the Museum für Kunsthandwerk, Frankfurt. The portraits of Ferdinand and his wife are derived from a 1523 medal by Hans Daucher of Augsburg

See also Alfred Walcher von Molthein, *Bunte Hafnerkeramik der Renaissance in den Oesterreichichen Ländern*, 1906

Annaliese Ohm, *Europäisches und Aussereuropäisches Glas*, Museum für Kunsthandwerk, Frankfurt, 1973, no. 118

Robert Schmidt, 'Die venezianischen Emailglässer des XV und XVI. Jahrhunderts', *Jahrbuch der K. preussischen Kunstsammlungen 32*, Berlin 1911

Maria Piatkiewicz-Dereniowa, *Keramos*, 76/77, p. 15 et. seq.

PROVENANCE:
From the Lanna Collection, Part II, 1911, lot 597.
From the Passavant-Gontard Collection, Frankfurt am Main, 1929, no. 192, pl. 67

£25,000 $46,237 DM95,937 (lot 296)

A RARE HISPANO-MORESQUE ARMORIAL CHARGER

Decorated in the centre with a coat-of-arms in blue and yellow on a manganese ground within a wide border of briony leaves and flowers in copper lustre and blue, the back with leaf-scrolls in copper lustre and blue; cracked.

18⅝in. diameter (47.5cm.) *Mid-15th Century, Valencia (Manises)*

A dish of the same period in the Cloisters Collection of the Metropolitan Museum is decorated with a coat-of-arms of a lion rampant within a border of similar garlic heads, said to be the arms of the degli Agli family of Florence. See an article by Timothy Husband 'Valencian Lustreware of the Fifteenth Century: Notes and Documents', the *Metropolitan Museum Bulletin*, Summer, 1970, p. 18, fig. 11

PROVENANCE:
Fürst Hohenzollern, Sigmaringen, inv. no. 721

£31,000 $57,334 DM118,962 (lot 295)

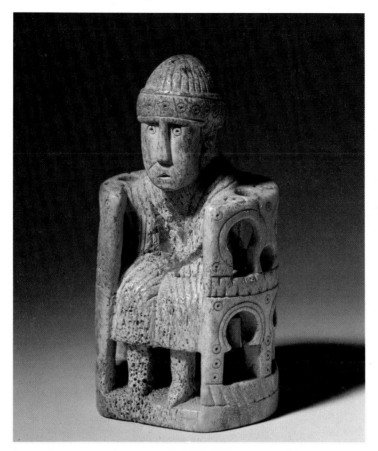

(*actual size*)

A NORTH EUROPEAN BONE CHESSPIECE

In the form of a beardless king, a cap or crown on his head and wearing a short tunic, seated on a high circular throne, the sides pierced with two rows of keyhole openings and decorated with zig-zag and ring-and-dot motifs.

$3\frac{3}{4}$*in. high* (9.7*cm.*) *Early 12th Century* (*?*)

PROVENANCE:
Found in Langenbogen bei Halle, Saxony, shortly before the middle of the 19th century.
Stapel Collection, Darmstadt

LITERATURE:
Bau- und Kunstdenkmäler des Provinz Sachsen, Der Mansfelder Seekreis, Heft 19, p. 287.
K. E. Förstemann, *Neue Mitteilungen aus dem Gebiet historischer-antiquarischer Forschungen,* Halle 1840, Band IV, 4, p. 147.
Goldschmidt, *Elfenbeinskulpturen,* III, no. 159

£45,000 $83,227 DM172,687 (lot 272)

Christ wearing a full robe over a long tunic, His right hand raised in blessing, His left supporting a heavily bound Gospel book on His knee, and seated on a high-backed bejewelled throne with His sandalled feet resting on a low footstool, a nimbed cross behind His head, to either side of which, carved in relief, are the abbreviations IC XC.

$9\frac{5}{8}in.$ *high by* $5\frac{1}{8}in.$ *(24.5cm. by 13cm.)* *Middle 11th Century, Constantinople*

In 1934, when Adolph Goldschmidt included this ivory in his corpus of Byzantine ivory carvings, it formed part of a silver bookcover, probably of 18th century origin, to which were also attached the nine nielli roundels in the Robert von Hirsch Collection (lot 274). One of these roundels bears the arms of Giuliano della Rovere, who is thought to be referred to in an inscription on the bookcover. This inscription read I R S C R A M D and was deciphered by Cardinal Ratti, later Pope Pius XI, as reading: I(ulianus) R(uere) S(avonensis) C(ardinalis) R(everendissimus, renovavit or restituit) A(nno) MD (1500)

This celebrated ivory belongs to the so-called 'Romanos' group in Adolph Goldschmidt's standard classification of the Byzantine ivories of the 10th to 13th centuries. The group is named after an ivory in the Cabinet des Médailles, Paris, which shows Christ crowning an imperial couple identified merely as 'Romanos Emperor of the Romans' and 'Eudokia Empress of the Romans'. The identity of the couple is uncertain. On one view they are the six-year-old Romanos II and his four-year-old bride Eudokia; on this view, the entire Romanos group, including the present ivory, would date from the middle of the 10th century. Recent research, however, has tended to support an alternative identification of the couple as Romanos IV and Eudokia Makrembolitissa, a view which, if accepted, would entail re-dating the Romanos group and the present ivory to the middle of the 11th century. Of the forty-seven Romanos group ivories catalogued by Goldschmidt, not more than two or three, of which this is the most important, are thought to be still in private hands

PROVENANCE:
(?) Cardinal Giuliano della Rovere, later Pope Julius II (1441–1513).
Trivulzio Collection, Milan

LITERATURE:
L. Courajod, 'L'exposition retrospective de Milan (Art Industriel 1874)', *Gazette des Beaux Arts*, April 1875, p. 377.
G. Schlumberger, *L'épopée byzantine à la fin du Xme siècle*, 1900, II, pl. 285.
A. M. Cust, *The Ivory Workers of the Middle Ages*, 1902, pl. 19.
G. Seregni, *Don Carlo Trivulzio e la cultura milanese dell'eta sua (1715–1789)*, 1927, pp. 203–204.
Goldschmidt and Weitzmann, *Die byzantinischen Elfenbeinskulpturen*, II, p. 41, no. 54, Abb. 21 and pl. XXII

£630,000 $1,165,185 DM2,417,625 (lot 273)

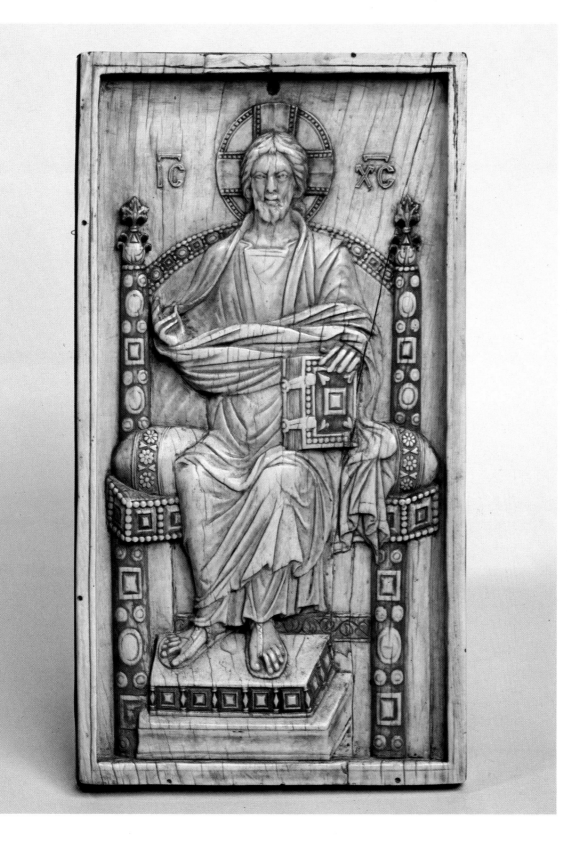

AN IVORY PLAQUE, PROBABLY FROM THE COVER OF A PSALTER

Carved in low relief with scenes from the Life of David disposed vertically in three zones amidst a richly wooded landscape, in the upper zone the battle between David and Goliath, with the beheading of Goliath to the left, in the middle zone David and the Lion, the Lion with a sheep held in his jaws, the rest of the flock behind a tree to the right, in the lower zone David as a Shepherd with the sheep and other animals arranged to left and right.

$6\frac{1}{8}$*in. high by* $2\frac{3}{4}$*in.* (*15.5cm. by 7cm.*) *Middle 10th Century, North Italian* (*Milan ?*) *or St Gall*

The reverse of this ivory shows evidence of having been used as a writing tablet. Fillitz suggests that it may originally have been a Late Antique ivory which underwent two successive transformations, firstly into a writing tablet and latterly into its present form

PROVENANCE:
Museo Civico, Volterra.
Spitzer Collection, Paris.
Fürsten Hohenzollern, Sigmaringen, inv. no. 6880

EXHIBITION:
Frankfurt am Main, 1928, no. 245

LITERATURE:
Description des ivoires de la ville de Volterra dont la vente aura lieu à Florence, 29th November, 1880, no. 5.
Goldschmidt, *Elfenbeinskulpturen*, I, no. 135.
Sprinz, *Bildwerke*, no. 2, pl. 2.
H. Fillitz, 'Die David-Platte einer Basler Privatsammlung', *Intuition und Kunstwissenschaft: Festschrift für Hanns Swarzenski*, Berlin 1973, pp. 223–231

£460,000 $850,770 DM1,765,250 (lot 276)
Wurttembergisches Landesmuseum, Stüttgart

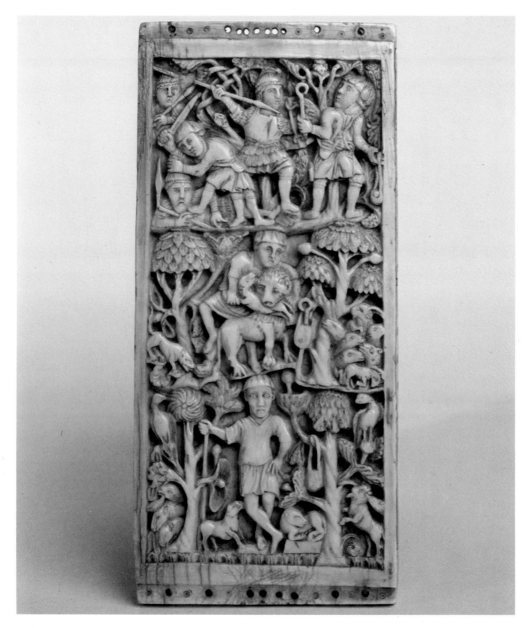

(*actual size*)

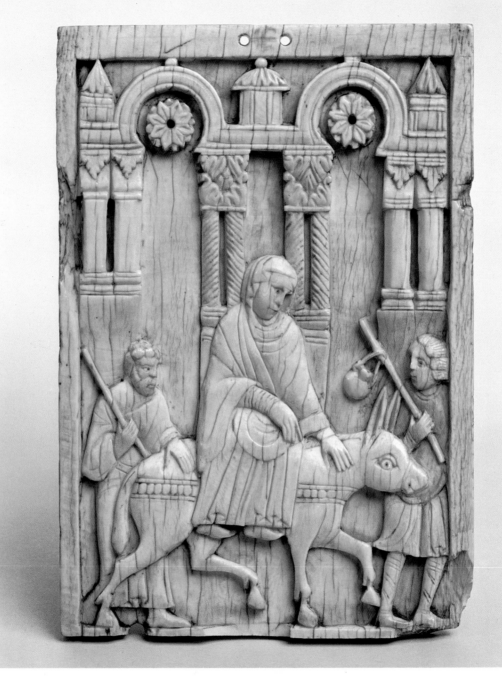

(actual size)

A SOUTH ITALIAN ROMANESQUE IVORY CARVING OF THE JOURNEY TO BETHLEHEM

In the foreground the Virgin on the back of a donkey, to the right a servant with stick and bundle over his right shoulder, to the left Joseph, his left hand placed on the donkey's hindquarters, in the background an architectural motif or screen with horseshoe arches on paired columns, small turrets on the top of the screen and rosettes between the arches.

6½in. high by 4½in. (16.5cm. by 11.5cm.) *Circa 1100 A.D.*

This plaque was associated by Goldschmidt with the workshop responsible for the celebrated ivory antependium in the cathedral treasury of Salerno (Goldschmidt, IV, no. 126ff; Lasko, pp. 144–146, R. P. Bergman, 'A School of Romanesque Ivory Carving in Amalfi', *Metropolitan Museum Journal*, 9, 1974, pp. 163–186). It is stylistically related to another ivory in the same group, a Visitation now in the Hermitage, with which it shares the same fantastic architecture (Goldschmidt, IV, no. 129)

PROVENANCE:
Fürst Hohenzollern, Sigmaringen, inv. no. 5211

EXHIBITION:
Frankfurt am Main, 1928, no. 258

LITERATURE:
Lehner, *Schnitzwerke*, no. 314.
Goldschmidt, *Elfenbeinskulpturen*, IV, no. 130.
Sprinz, *Bildwerke*, no. 1, pl. 1.
Fillitz, *Zwei Elfenbeinplatten*, p. 14, fig. 7

£190,000 $351,405 DM729,125 (lot 277) Cleveland Museum of Art

A FRENCH GOTHIC IVORY DIPTYCH

The two leaves divided into three registers with pointed trifoliated arches and carved in high relief with scenes from the Passion of Christ; from the bottom left, the Betrayal, the Arrest in the Garden, Christ brought before Pilate, the Scourging of Christ, the Death of Judas, the Flagellation, the Washing of the Hands, the Carrying of the Cross, the Crucifixion, the Descent from the Cross, the Entombment, the Noli me Tangere and the Harrowing of Hell.

7¼in. by 7⅝in. (18.5cm. by 19.5cm. open) *About* 1300

This ivory is stylistically close to the celebrated diptych in the Victoria and Albert Museum which is said to come from Saint-Jean-des-Vignes at Soissons (Koechlin, *Ivoires Gothiques*, no. 38)

PROVENANCE:
Spitzer Collection, Paris, 1893, no. 210.
Fürst Hohenzollern, Sigmaringen, inv. no. 7289

EXHIBITION:
Frankfurt am Main, 1928, no. 246

LITERATURE:
Sprinz, *Bildwerke*, no. 7, pl. 5

£58,000 $107,271 DM222,575 (lot 285)

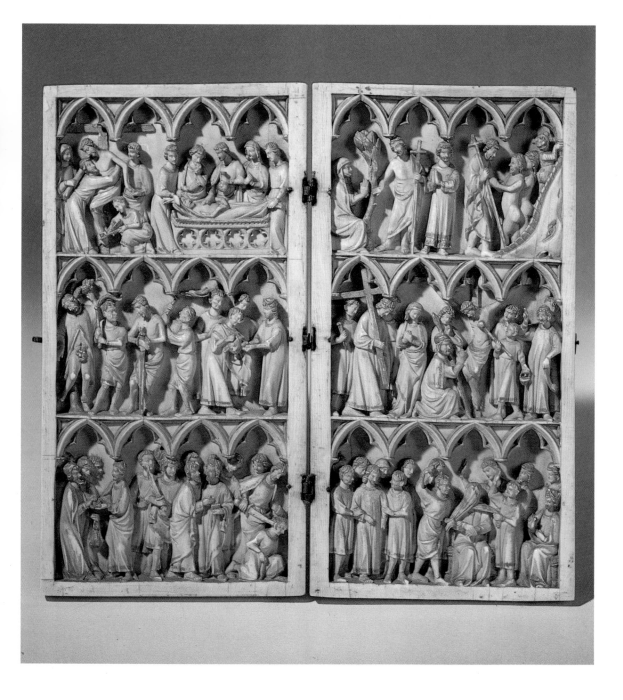

A BRONZE FIGURE OF THE YOUNG HERCULES

The young god standing with his weight on his right foot, his left slightly raised, gazing upwards to the left and holding an apple of the Hesperides in his left hand, a club in his right hand, the muscles vigorously modelled and the whole with a rich reddish brown patina.

13⅜in. high (34cm.) *Early 16th Century, Florentine*

While this bronze clearly shows the influence of Bertoldo, in particular the battle reliefs in the Museo Nazionale, Florence, the form is less attenuated and the muscles slacker and more rounded. Such a form is more likely to be connected with the reliefs in the Scala-Gherardesca, the Florentine palace by Guiliano da Sangallo, completed before 1492. The exact sculptor of the reliefs themselves has not been identified, but an early attribution to Bertoldo has been replaced by one to a group of pupils of Bertoldo in the Medici Academy, including Giovanni Francesco Rustici and Benedetto da Rovezzano, who worked with Sangallo in the Palazzo Gondi. Michelangelo was also for a short time a pupil at this academy and his influence is referred to by Pope-Hennessy in his article 'A fountain by Rustici' where he discusses the figure surmounting the fountain, formerly at Woolbeding, Sussex and now in the Victoria and Albert Museum. He relates the figure to two Leonardo drawings and that of a male nude, in the Royal Collection, Windsor, Inv. no. 12591r., with the head turned to the left and right arm raised, the left arm down, is especially relevant to the present bronze. The article concludes as follows: 'In 1505 or the first half of 1506, when Leonardo was in Florence, he became interested in a proposal for designing a small fountain and made at least two drawings for the central figure. Since he was at this time closely involved with Rustici, the latter was entrusted with the working up and executing the commission. The posture of his central figure, like that of the central figure planned by Leonardo, was influenced by Michelangelo's marble David'.

A bronze Mercury in the Victoria and Albert Museum, which has a very similar pose to the present bronze, is clearly a Venetian interpretation of a Michelangelesque subject, perhaps taken from a Tintoretto drawing such as that in Christ Church, Oxford, illustrated by Weihrauch, *Europäisches Bronzestatuetten*, pl. 551. Another bronze which shows certain similarities in the loose-limbed pose, to the present bronze, is the Hercules, formerly in the Pfungst collection and now in the Frick Collection, New York. This bronze was formerly related by Bode to both Pollaiuolo, Bertoldo and Verrocchio. Bode finally concluded that it was by a contemporary of both Pollaiuolo and Verrocchio, who had yet to be identified. Pope-Hennessy, in the Frick catalogue, ascribed the bronze to the end of the first or beginning of the second decade of the 16th century and again connects the bronze, in the pose, but not the modelling, with Rustici and his school. It can therefore be concluded that the present bronze with its influence from Bertoldo and Pollaiuolo, but also with certain features of Michelangelo, must come from one of the Florentine pupils of Bertoldo, such as Rustici or Rovezzano, and date from the early part of the 16th Century

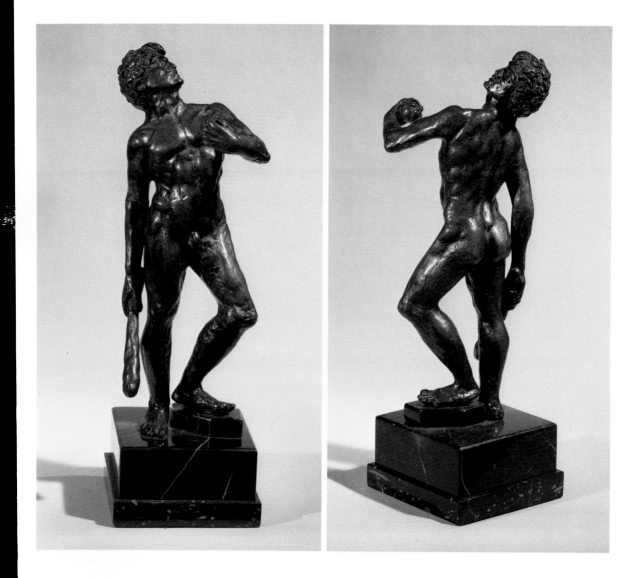

PROVENANCE:
Schloss Friedrichshof, Kronberg

LITERATURE:
P. Sanpaolesi, 'La Casa Fiorentina di Bartolommeo Scala', *Studien zur Toskanischen Kunst: Festschrift für L. H. Heydenreich*, Munich, 1964, pp. 285–286.
Pope-Hennessy, *Catalogue of Italian Sculpture in the Frick Collection*, pp. 43–53.
Pope-Hennessy, 'A Fountain by Rustici', *Victoria and Albert Museum Year Book*, 1974, Vol. 4

£42,000 $77,679 DM161,175 (lot 339)

(actual size)

A CAST AND PIERCED FRENCH BRONZE MOUNT FROM THE SOUVIGNY BIBLE IN THE LIBRARY OF MOULINS

Rectangular, the central area in relief formed as a horned dragon whose winged body terminates in a spiral, the detail finely engraved, the corners engraved with vermiculé scrollwork, and pierced with fixing holes.

2in. square (5cm.) *12th/13th Century, Limoges*

The rebinding of the Souvigny Bible took place in 1833 after the original binding had been lost. The present binding retains six plaques of similar but variant designs

PROVENANCE:
Moretti, Moulins.
de Lannoy, Paris.
Figdor, Vienna, see sale Catalogue, Berlin 1930, no. 447

LITERATURE:
E. Viollet-le-Duc, *Dictionnaire du Mobilier*, II, 1871, p. 191.
J. Moret, 'Note relative à la découverte d'un mascaron de bronze scuplté provenant de la Bible de Souvigny', *Revue Bourbonnaise*, 1884, p. 291.

£16,000 $29,592 DM61,400 (lot 238) The town of Moulins

A BRONZE SEATED PUTTO

The child with a short classical tunic draped over the left shoulder, holding a lance in his right hand and supporting a shield with the arms of the Arigoni family of Rome with his left, perhaps a model for a funeral monument, black patina, marble base.

6⅛in. high (15.5cm.) *Early 16th Century, Italian*

PROVENANCE:
R. von Kauffmann Collection, Berlin, 1917, Sale Catalogue, Vol. III, no. 227, pl. 7

REFERENCE:
Rietstap, Armorial Général, Vol. 1, p. 64

£20,000 $36,990 DM76,750 (lot 342)

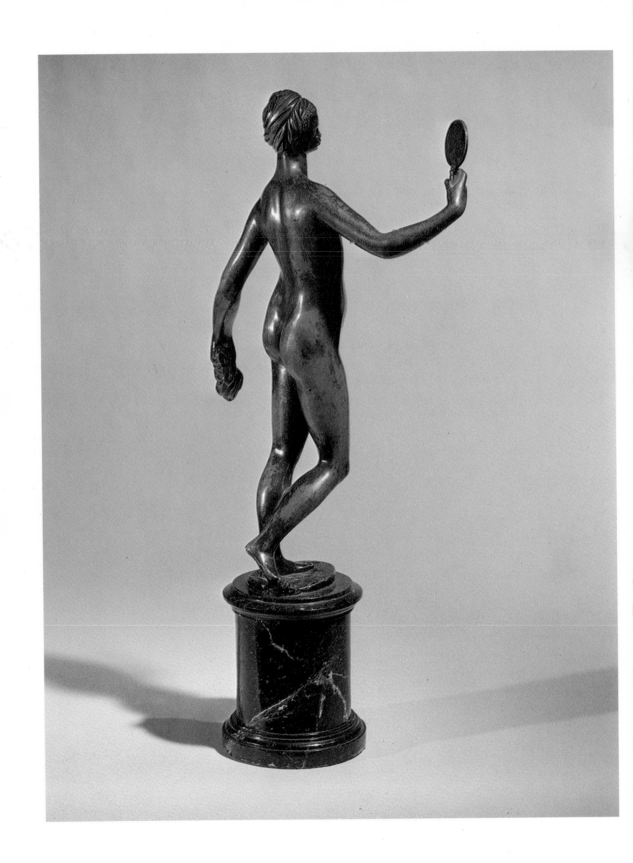

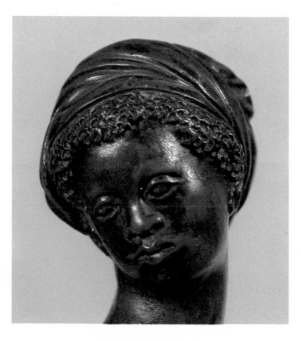

A FINE VENETIAN BRONZE FIGURE OF A NEGRESS WITH A MIRROR

The naked woman stands with her weight on her left foot, a handkerchief in her left hand and a mirror in her outstretched right hand, a turban on her tightly curled hair, oval base, red brown lacquer over pale brown patina, red and green marble socle.

13in. high (30.5cm.) *Second half 16th Century, attributed to Danese Cattaneo (1509–1573)*

Other examples of this fine bronze formerly attributed to Alessandro Vittoria by Planiscig and Bode are in the Kunsthistorisches Museum, Vienna, the Brunswick and Grenoble Museums, and the Louvre, formerly in the collection of the Marquise de Ganay, sold Paris, 1922, no. 84; another was in the collection of Maurice Kann, sold Paris 1910, no. 349 and another formerly in the Castiglioni collection, Vienna, sold Amsterdam, November, 1925, Part II, no. XLIX, now in the Metropolitan Museum, New York

PROVENANCE:
Pringsheim Collection, Munich

REFERENCES:
Planiscig, *Venezianisches Bildhauer*, 1921, p. 495, pl. 527–8.
W. v. Bode, *Italienische Bronzestatuetten*, 1906 Edition, Volume I, p. 43, pl. 83.
Weihrauch, *Europäische Bronzestatuetten*, p. 145, pl. 166.

£62,000 $114,669 DM237,925 (lot 344) Liebighaus Museum, Frankfurt

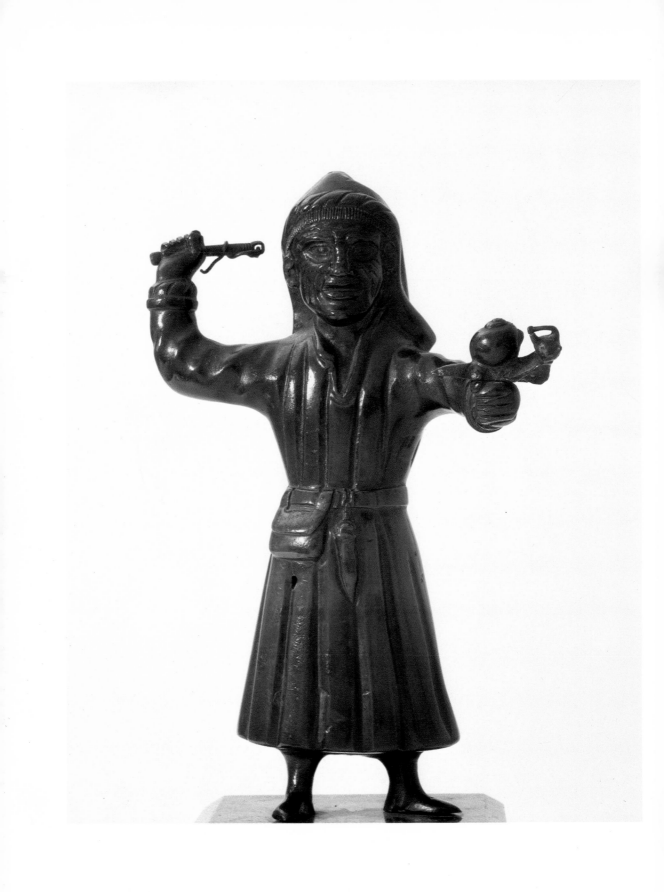

A BRONZE ALLEGORICAL FIGURE OF A MAN CASTIGATING SLOTH

The figure clad in a simple belted tunic, a purse and a knife at his waist, wears a long backed headdress, brandishes a whip in his right hand and a snail sits on his left wrist, his features modelled with grinning expression

9½in. high (24cm.) Mid-15th Century, Flemish

The style both of dress and of the model of this figure are apparently related to that of Philippe de Neven, one of three figures preserved (now in the Rijksmuseum) from around the tomb of Isabella of Bourbon, attributed to a model cast by Jacques de Gerines of Brussels, died 1463, and completed by Renier van Thinen, active in Brussels, 1465–1494, although the present bronze probably dates from a little earlier, about 1440–50. This bronze probably illustrates a proverb and alludes to Inertia. However the meaning of these allusions is always speculative and remains somewhat enigmatic

REFERENCE:
Theodor Müller, *Sculpture in the Netherlands*, p. 92, pl. 107a

£44,000 $81,378 DM168,850 (lot 321)

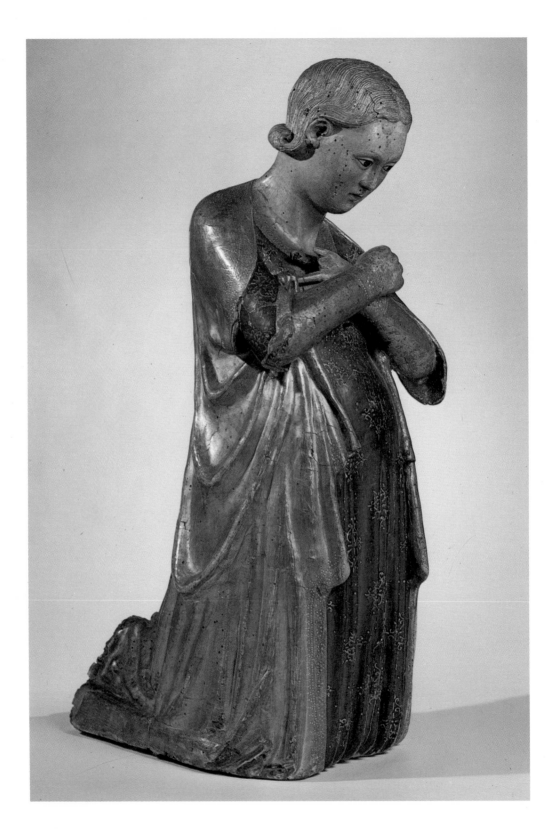

A POLYCHROME WOOD FIGURE OF THE VIRGIN

She is shown kneeling with her arms folded across her breast in prayer and her head cast down, perhaps from an Annuciation group, her short hair parted in the centre, curled at the ends and gilded, wearing a gilded cloak falling in regular folds to her feet, beneath her cloak a blue dress decorated with gilded arabesques, both garments with punctate gilded borders.

24¾*in. high (63cm.)* *Circa 1450, Siena*

The same short centrally parted hair, the strong black eyes, small mouth and elegant elongated lower body is found in the Sienese standing Virgin from an annunciation group in the Bardini Museum, Florence

REFERENCE:
Enzo Carli, *Scultura Lignea Senese*, 1951

£75,000 $138,712 DM287,812 (lot 383)
The Thyssen-Bornemisza Collection, Lugano, Switzerland

A WALNUT POLYCHROME GROUP OF THE VIRGIN AND CHILD

The Virgin of Humility carved in high relief in an almost circular composition with her right leg forming the base as she is seated on a dark red cushion tenderly holding the Child within her left arm, her right hand holding His right foot, she is shown bare headed with long waving hair, a blue scarf around her neck, she wears a dark red dress and a blue shawl over her lap, the Child is naked and reaches up to His mother laughing as she smiles lovingly at Him.

26¾in. high (68cm.) Circa 1470, Ferrara

Charles Seymour and Hanns Swarzenski related this group to the Madonna of Humility by Jacopo della Quercia in the National Gallery, Washington. Eberhard Ruhmer links it to Ferrara and the influence of Cosimo Tura.

For the turn of the head and the tender expression of the Virgin compare with the Virgin of the Annunciation painted by Tura in 1469 on the organ shutter in the Duomo at Ferrara; for the laughing child, compare with an angel supporting the right side of the Christ of the Pieta in the lunette to the Roverella altarpiece by Tura in the Louvre. This is echoed in the relief of the Pieta with Christ, the Virgin, Magdalen and St. John in stone from a sarcophogus, attributed to Ferrara, end of the 15th century, in Schottmüller's 1913 *Catalogue* of the former Kaiser Friedrich museum no. 277. The Magdalen in that group is particularly relevant to this sculpture

LITERATURE:
Seymour and Swarzenski, 'A Madonna of Humility', *Gazette des Beaux Arts*, 1947, pp. 149–150.
Eberhard Ruhmer, 'Zur Plastischen Tätigkeit des Cosimo Tura', *Pantheon*, III, Vol. XVIII, pp. 149–151

£110,000 $203,445 DM422,125 (lot 382)

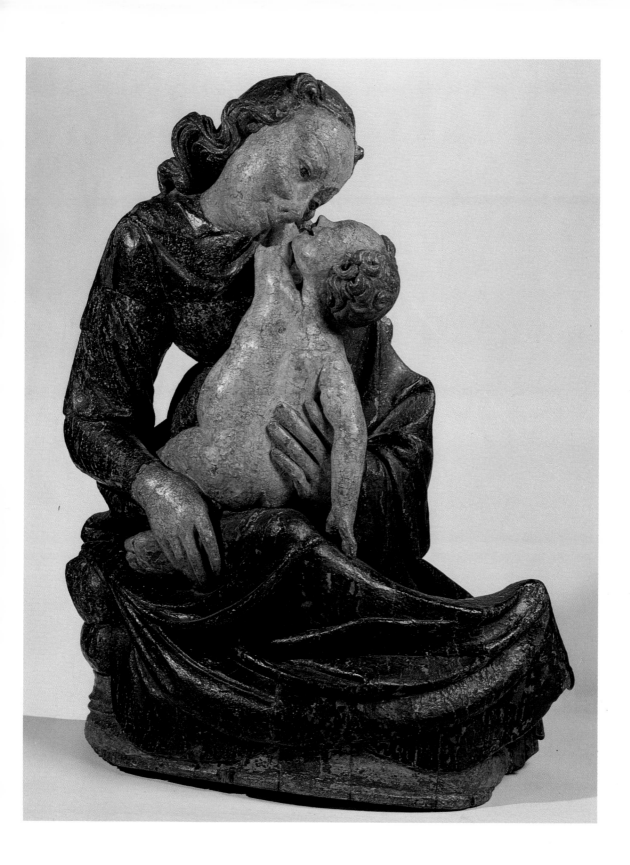

AN ALABASTER GROUP OF THE PIETA

The Virgin seated on a bench with a veil over her head and elaborately carved V-shaped folds to her robes, supports the dead Christ across her knees.

9¾in. high (25cm.) Circa 1430, South Netherlandish, from the circle of
 the so called Master of Rimini

The name Master of Rimini was given by Swarzenski to the Cologne master Gusmin, who was active in Italy as a goldsmith. A Pieta by the same master entitled the Madonna dell'Acqua is in S. Francesco at Rimini and an alabaster figure of St. Christopher disappeared during the war from the Museo Civico at Padua. An altar piece, with many figures, similar to that in the Liebieghaus, Frankfurt, donated in 1442 to S. Maria Podone in Milan, is now in the Palazzo Borromeo on Isola Bella in Lake Maggiore. This altar piece is apparently the work of several different artists working in the style of the Master of Rimini. An exhibition of the Sculpture of the Middle Rhine, circa 1400, included two Pieta groups similar to the present example, one from the Master of Rimini, himself, circa 1430 and the other described as German, circa 1440, in which both the drapery and the headdress bear considerable resemblance to the present alabaster.

PROVENANCE:
Lempertz, Cologne, sale December, 1926, no. 82

REFERENCES:
Swarzenski, Deutsche Alabasterplastik des 15. Jahrhunderts, Städeljahrbuch, Vol. 1, 1921, p. 167.
Catalogue, Gottische Bildwerke aus dem Liebieghaus, Frankfurt am Main, 1966, nos. 12–15.
Exhibition Catalogue, Kunst um 1400 am Mittelrhein, Liebieghaus Museum, Frankfurt am Main, December 1975, nos. 118 and 119.

£25,000 $46,237 DM95,937 (lot 388)

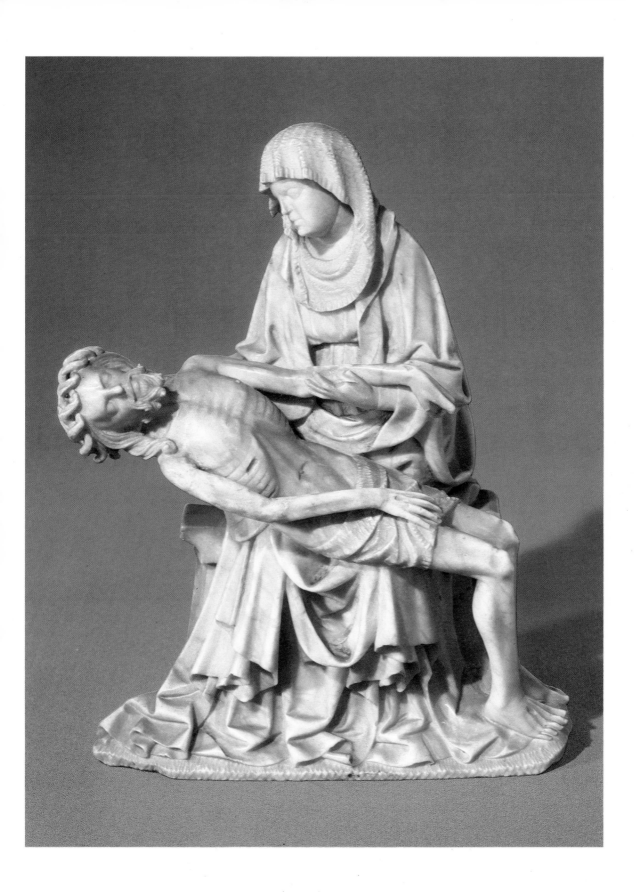

A PEARWOOD FIGURE OF ST. HELENA

The young female saint shown standing wearing a small crown, with long tresses of hair falling down her back, she turns to dexter holding up the drapery of her cloak in her right arm, her left outstretched, the rest of his robes swirling about her.

11 in. high (28cm.)

First half 18th Century, attributed to the Feuchtmayer workshops, Lake of Constance

Erich Steingräber believes that this figure was the model for the Goggingen fayence figure of St. Helena in the Bavarian National Museum. He believed the master to have been located somewhere in Swabia between Augsburg and the Lake of Constance. The exaggerated drama of the gestures and the drapery and the facial expression confirm the attribution to the Feuchtmayer family, whose main work was in the Bodensee area, close to Memmingen where the Goggingen factory was situated.

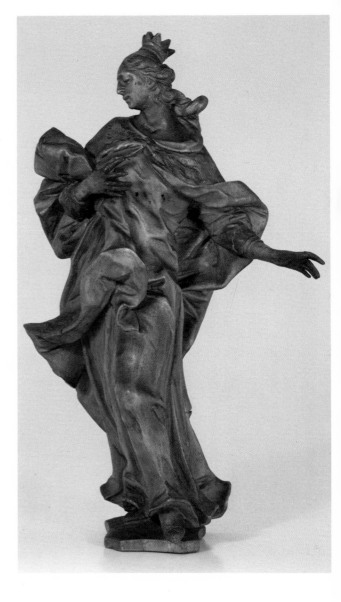

LITERATURE:
Eric Steingräber, Ein Beitrag zur Fayence-Plastik, *Pantheon*, 18 Jahrg. 1960, no. 1, pp. 32–34.
Boeck, *Feuchtmayer Meisterwerke*, 1963 for comparison

£9,000 $16,645 DM34,537 (lot 403) Edward R. Lubin, New York

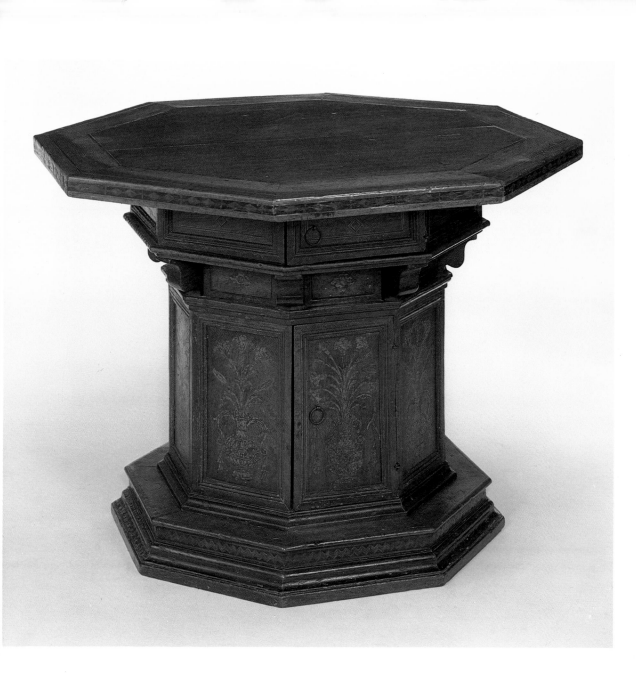

A FLORENTINE WALNUT INTARSIA TABLE

The octagonal top with a broad banding, with a frieze cupboard and two frieze drawers, the panelled pedestal inlaid with vases of flowers and with two cupboards, on a moulded plinth; central panel of top replaced.

2ft. 7½in. high by 3ft. 5in. wide (80cm. by 104cm.) *Circa 1500*

Illustrated: Mario Tinti, *Il Mobilio Fiorentino*, plate cxx.

£23,000 $42,274 DM88,262 (lot 648)

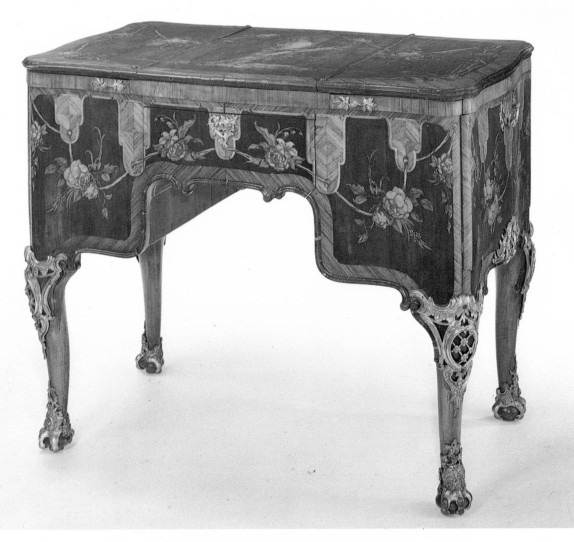

A MAGNIFICENT AND HIGHLY IMPORTANT MARQUETRY COIFFEUSE MADE BY ABRAHAM ROENTGEN FOR FRIEDRICH AUGUSTUS III, ELECTOR OF SAXONY

The whole finely inlaid with ribbon-tied panels of flowers in a variety of natural and green-stained woods on harewood within kingwood crossbandings, of serpentine rectangular form, the triple divided top with a central panel inlaid on the underside partly in mother of pearl with the crowned coat of arms of the House of Saxe-Wettin, Quarterly: I and IV Poland, II and III Lithuania, overall an escutcheon with the arms of the Electorate of Saxony, and the date 1769 and enclosing a bevelled mirror; the kneehole frieze containing a spring-operated drawer with a hinged and adjustable three-flap writing surface enclosing a gilt-mounted metal inkwell and pounce pot, drawers and pigeonholes and with open compartments, flanked by inlaid spring-operated quadrant-shaped platforms; each end with a hinged panel revealing a swivelling safe cupboard inlaid with a floral trellis with a hinged lid and secret drawers; the incurved legs with finely cast gilt-metal mounts, the knees with pierced trelliswork and the feet with floral claws.

2ft. 8½in. high by 3ft. 3¼in. wide by 2ft. deep (82cm. by 100cm. by 61cm.) Dated 1769

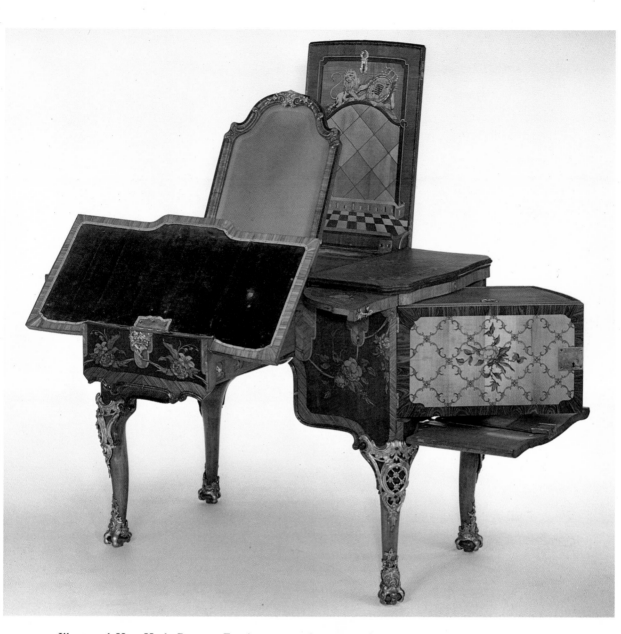

Illustrated: Hans Huth, *Roentgen Furniture*, 1974, plates 133 and 134.
Adolf Feulner, *Kunstgeschichte des Möbels*, figure 453.

Huth suggests that the order for this coiffeuse may have come to Abraham Roentgen on the recommendation of Prince Clemens August of Saxony, who in 1768 had succeeded Johann Philipp von Walderdorff as Elector of Trier. Abraham's finest achievement was the sécrétaire, now in the Rijksmuseum, Amsterdam, he made for Walderdorff about 1765. This resembles the coiffeuse in general character though it is even more profuse and varied in its marquetry. The coiffeuse provides a compromise between French and German fashion, with a French style tripartite top and Germanic claw and ball feet. The lavish rococo mounts would not have been fashionable in Paris by the late 1760's. The marquetry sprays of flowers suspended from ribbons, conform to the type used by David Roentgen in the 1780's.

Friedrich Augustus III, later King of Saxony, born 1750, married 1769 Marie Amalie Auguste, daughter of Friedrich Michael, Count Palatine of Zweibrucken-Birkenfeld-Bischweiler.

£200,000 $367,600 DM767,500 (lot 598) Unspecified German Museum

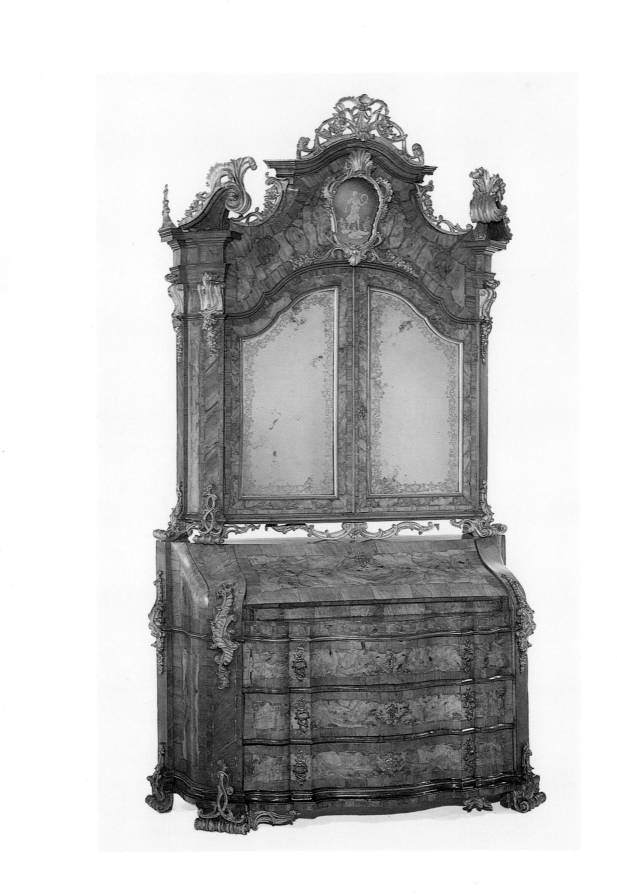

A FINE VENETIAN PARCEL-GILT WALNUT BUREAU CABINET

With panels of burr-wood enclosed by broad crossbandings and the whole enriched by delicately carved giltwood scrollwork; the serpentine-topped upper part applied with an oval mirrored cartouche engraved with Diana above a pair of mirrored doors engraved with delicate strapwork borders and enclosing shelves, the canted corners with projecting corbels and raised on four low scroll feet; the lower part with an ogee flap enclosing drawers and a well, with three serpentine-fronted drawers below and with canted corners and shaped sides.

9ft. 4in. high by 5ft. 3in. wide by 2ft. 2in. deep *Mid-18th Century*
(284cm. by 160cm. by 66cm.)

Illustrated: Adolf Feulner, *Kunstgeschichte des Möbels*, plate 344.

£50,000 $91,900 DM191,875 (lot 627)

AN EXTREMELY RARE MEISSEN WHITE FIGURE OF A LARGE MACAW (*Arar macao*)

Modelled *by Johann Joachim Kaendler*, the bird perched on an oak stump with its head turned slightly to its left, its long tail protruding below the base which is modelled with leaves on one of which is a beetle, its left claw holding a cherry twig, its wings held close to the body; large firing crack.

26¼in. from head to base (67cm.), 38½in. overall (97cm.) 1732–5

From the series of large birds and animals ordered by Augustus the Strong for the Japanese Palace in Dresden. The species represented seems to be the Scarlet Macaw (Ara macao), best known of all the South American parrots. Living examples were brought to Europe from as early as the 16th century, and it is quite possible that there was a live specimen in Dresden in the aviary at Schloss Moritzburg in 1731; alternatively it may have been modelled from a stuffed specimen in the Kunstkammer in Dresden. Dr Ingelore Menzhausen, Director of the Porcelain Collection in Dresden, has pointed out that it is referred to in the Meissen records as an "Indianische Raben" (Indian Raven). Although only four were ordered in fact fourteen were delivered, of which the first four had been made in unfired porcelain by 17th December 1731 (*Was in der rohen Masse ausgeformet und verfertiget stehet . . . 4 Stück Indianischen Raben gross*). By the 18th August 1732, ten were described as 'well fired' (*Gutebrannte Stück*) and four as 'unfired pieces' (*rohe Stück*). On the 17th November 1733 "1 Indianische Raben" is mentioned among the enamelled wares (*an emalirten Porcellain Geschirren*)

The inventory of 1779 mentions twelve of these birds all with some damage and presumably undecorated. It also mentions on p. 16 as No. 270 one Indian Raven with red and blue colouring on a tall base, very damaged. (*Ein Indianische Rabe mit roth und blauen Farben, auf hohe Postament, 1 Elle 6 Zoll hoch, sehr schadthrafft, No. 270*). This coloured macaw is still in the Dresden Collection but "married" to another, undamaged base

See J. L. Sponsel, *Kabinettstücke der Meissner Porzellan-Manufaktur von J. J. Kaendler*, 1900, pp. 99 and 229; Berling, *Festschrift*, 1910, col. pl. 1 (a coloured reproduction, from the original moulds); Carl Albiker, *Die Porzellantiere im 18. Jahrhundert*, Berlin 1935, no. 43, pl. XIV and pp. 34–5 and the same author's 2nd edition 1959, nos. 50–1; and Helmuth Groger, *Johann Joachim Kaendler*, 1956, pp. 33–4.

PROVENANCE:
From the Dresden Collection Sale of Duplicates from the Johanneum, 12th–14th October 1920, lot 189, ill. pl. 13.

£105,000 $194,197 DM403,462 (lot 661)
Kunstgewerbemuseum der Stadt Köln (Cologne)

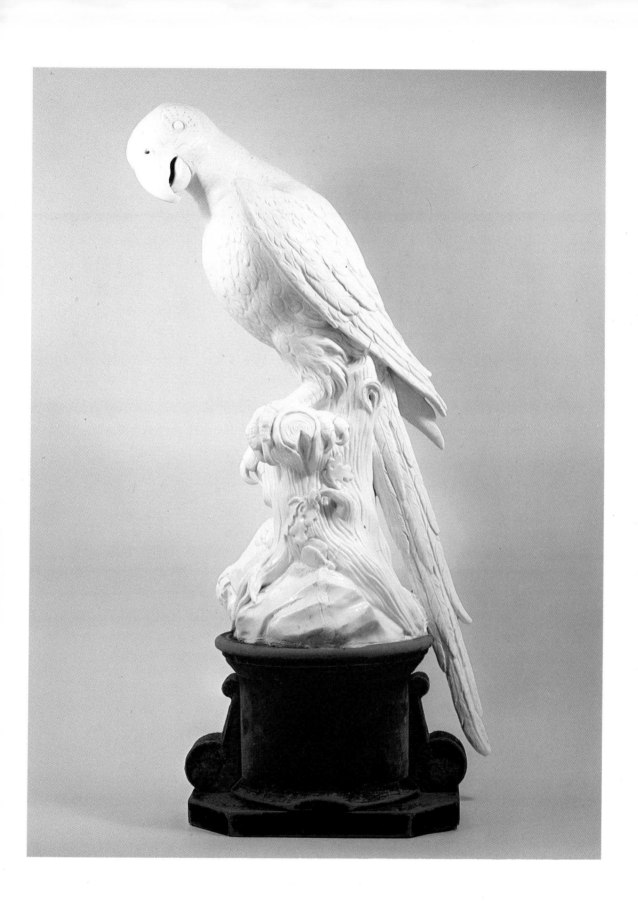

JEAN-BAPTISTE-CAMILLE COROT

NOURRICE ALLAITANT

oil on canvas, stamped with the mark of the Vente Corot; the red seal of the Vente Corot on the stretcher

18in by 14¾in 45·8cm by 37·5cm

Painted *circa* 1860–65.

PROVENANCE:
Vente posthume Corot, 26–28 May 1875, no. 135, 1500 francs;
Jean Dollfus, Paris (vente, Paris, Galerie Georges Petit, 2 March 1912, no. 14, 12,100 francs;
Durand Ruel, Paris (sold to von Hirsch in December 1922).

EXHIBITED:
Bern, Kunstmuseum, *Corot*, January–March 1960, no. 70 (reproduced in the catalogue).

LITERATURE:
Alfred Robaut, *L'Œuvre de Corot*, H. Floury, Paris 1905, vol. III, no. 1383 (reproduced);
Julius Meier-Graefe, *Corot*, Cassirer, Berlin 1930, plate LXXV;
Gaston Bernheim de Villers, *Corot, Peintre de Figures*, Paris 1930, no. 214 (reproduced).

£60,000 $110,940 DM230,400 (lot 711)

PIERRE-AUGUSTE RENOIR

LES PATINEURS À LONGCHAMPS

oil on canvas, signed and dated '68

28⅜in by 35⅜in 72cm by 90cm

Renoir is reported as commenting about this painting as follows:
"Le Bois de Boulogne avec des patineurs et des promeneurs. Je n'ai jamais supporté le froid, aussi, en fait de paysages d'hiver, il n'y a que cette toile . . . Je me rappelle aussi deux ou trois petites études. Et d'ailleurs, même si l'on supporte le froid, pourquoi peindre la neige, cette lèpre de la nature?" (Vollard, 1920, p. 51).

PROVENANCE:
Ambroise Vollard, Paris.

EXHIBITED:
Frankfurt-am-Main, Städelsches Kunstinstitut, *Vom Abbild zum Sinnbild*, June–July 1931, no. 200;
Basel, Kunsthalle, *Pierre-Auguste Renoir*, February–March 1934, no. 134;
Basel, *Basler Privatbesitz*, no. 316.

LITERATURE:
Ambroise Vollard, *Les Tableaux, Pastels et Dessins de Pierre-Auguste Renoir*, Paris 1918, vol. I, p. 5, no. 18 (reproduced);
Ambroise Vollard, *La Vie et l'Œuvre de Pierre-Auguste Renoir*, Paris 1919, p. 48;
Ambroise Vollard, *Renoir*, G. Crès Editeurs, Paris 1920, p. 51;
Julius Meier-Graefe, *Renoir*, Klinkhardt und Biermann Verlag, Leipzig 1929, p. 20, no. 8 (reproduced);
Georgine Oeri, *Kunstwerke des 19. Jahrhunderts aus dem Basler Privatbesitz*, Holbein, Basel 1944, plate 43;
Michel Drucker, *Renoir*, Editions Pierre Tisné, Paris 1944, no. 11 (reproduced); second edition, 1955, no. 9 (reproduced);
John Rewald, *The History of Impressionism*, Museum of Modern Art, New York 1946, p. 167 (reproduced), 1961 and 1973 editions, p. 298 (reproduced);
Germain Bazin, *L'Epoque Impressionniste*, Editions Pierre Tisné, Paris 1947, plate 16;
William Gaunt, *Renoir*, Phaidon Press, London 1952, plate 4;
Paris d'Autrefois de Foucquet à Daumier, Editions Skira, 1957, colour plate p. 118;
M. Gilbert, *Le Bois de Boulogne*, Bibliothèque des Arts, Paris 1958, p. 145(reproduced)
E. Fezzi, *L'Opera completa di Renoir, nel periodo impressionista 1869–1883*, Rizzoli Editore, Milan 1972, no. 28 (reproduced);
François Daulte, *Auguste Renoir*, Fabbri, Milan 1972, p. 75 (reproduced);
Kermit Swiler Champa, *Studies in early Impressionism*, Yale University Press, New Haven and London 1973, p. 57, figure 78;
Keith Wheldon, *Renoir and his Art*, Hamlyn, London 1975, plate 25.

To be included in Volume IV (*Les Paysages*) of the *Renoir Catalogue Raisonné* being prepared by François Daulte.

£160,000 $295,840 DM614,400 (lot 717)

PIERRE-AUGUSTE RENOIR

LA DANSE, ETUDE POUR LE MOULIN DE LA GALETTE

oil on canvas, signed

17⅛in by 10½in 45·3cm by 26·7cm

Painted in 1876, this is a study for the couple dancing in the foreground on the left hand side of the *Moulin de la Galette*.

The girl, one of Renoir's models, was Marguerite Legrand (called Margot) and the man was Pedro Vidal de Solarès y Cardenas, a young painter from Cuba. Georges Rivière, Renoir's friend and biographer who also appears in *Le Moulin de la Galette*, described them as follows in *Renoir et ses Amis*, Paris 1921: *"Margot avait des cheveux châtain terne peu abondants, des sourcils clairsemés et ses paupières aux bords rouges étaient dépourvues de cils. Le nez un peu gros semblait se caler entre les joues rebondies, comme entre deux oreillers, et la bouche sensuelle, aux lèvres sanglantes et épaisses, se plissait parfois d'un sourire dédaigneux. Margot était bruyante. Elle réalisait, en somme, le type canaille de la faubourienne. . . Peu de modèles ont mis autant que Margot la patience de Renoir à l'épreuve."* (p. 66).

"Solarès était un brave garçon, toujours de bonne humeur et d'une inépuisable complaisance. Pendant les séances, l'insouciante et exubérante Margot secouait vivement le grand diable de Solarès, qu'elle trouvait compassé. Elle le faisait pivoter en dansant une polka, lui chantait des refrains canaille et lui apprenait des mots d'argot, que l'autre écorchait toujours. Solarès s'efforçait de devenir parisien, et il croyait que Margot l'y aidait de ses leçons." (p. 137).

PROVENANCE:

Ambroise Vollard, Paris;

Paul Rosenberg, New York (purchased from the Vollard heirs in June 1951 and sold to von Hirsch in November 1951).

LITERATURE:

François Daulte, *Auguste Renoir, Catalogue Raisonné de l'Œuvre peint. I figures 1860–1890*, Editions Durand-Ruel, Lausanne 1971, no. 205 (reproduced);

E. Fezzi, *L'opera completa di Renoir nel periodo impressionista 1869–1883*, Rizzoli Editore, Milan 1972, no. 246 (reproduced).

£80,000 $147,920 DM307,200 (lot 719)

HENRI DE TOULOUSE-LAUTREC

LA ROUSSE AU CARACO BLANC

oil on canvas, signed

23⅜in by 19in 59·5cm by 48·2cm

Painted in 1889.
The model was Carmen Gaudin, a young working girl who posed for Lautrec, Rachou and Gauzi, whose photograph of her is reproduced in P. Huisman and M. G. Dortu, *Lautrec par Lautrec*, Lausanne and Paris 1964, page 52. Lautrec painted her a number of times at that period, see Dortu numbers P. 305, 317, 343, 346, 352 and 353.

PROVENANCE:
M. Jullien, Paris;
Bernheim-Jeune, Paris (purchased from Jullien on 4 March 1904 and sold in 1907 to von Hirsch, whose first purchase this was).

EXHIBITED:
Paris, Galerie Bernheim-Jeune, *Toulouse-Lautrec,* October 1908, no. 23.

LITERATURE:
Maurice Joyant, *Henri de Toulouse-Lautrec,* H. Floury, Paris 1926, vol. I, catalogued p. 268, p. 88 (reproduced);
Pierre MacOrlan, *Lautrec,* H. Floury, Paris 1934, p. 31 (reproduced);
Emile Schaub Koch, *Psychanalyse d'un Peintre moderne,* Editions Littérature Internationale, 1935, pp. 178 and 186;
Jacques Lassaigne, *Toulouse-Lautrec,* Hyperion, Paris 1939, p. 56 (reproduced);
Georgine Oeri, *Kunstwerke des 19. Jahrhunderts aus dem Basler Privatbesitz,* Holbein, Basel 1944, no. 52 (reproduced);
Leonardo Borghese, *Toulouse-Lautrec,* Ulrico Hoepli 1945, plate VII;
G. Caproni and G. M. Sugano, *L'Opera completa di Toulouse-Lautrec,* Rizzoli Editore, Milan 1969, no. 230 (reproduced);
Dortu, *Toulouse-Lautrec,* vol. II, no. P. 345 (reproduced).

£230,000 $425,270 DM883,200 (lot 724)

EDGAR DEGAS

LYDA, FEMME À LA LORGNETTE

peinture à l'essence on paper laid down on canvas, signed twice and inscribed *Lyda*

14¼in by 9in 36·2cm by 23cm

Painted *circa* 1869–72, Degas did three other studies of this figure, Lemoisne nos. 179, 268 and 431.

PROVENANCE:
Puvis de Chavannes, Paris;
A. Duhamel;
Durand-Ruel, Paris (purchased from Duhamel on 5 December 1898);
Eggisto Fabbri, Florence.

EXHIBITED:
Paris, Galerie Georges Petit, *Degas,* April–May 1924, no. 60;
Basel, *Basler Privatbesitz,* no. 308.

LITERATURE:
Georges Grappe, *Degas,* in "L'Art et le Beau", 3ème année, 1911, I, p. 38 (reproduced);
P.–A. Lemoisne, *Degas,* Librairie Centrale des Beaux-Arts, Paris 1912, p. 70 (reproduced);
Paul Lafond, *Degas,* H. Floury, Paris 1918–19, vol. II, p. 18 (reproduced);
Julius Meier-Graefe, *Degas,* Ernest Benn, London 1923, plate 41;
Julius Meier-Graefe, *Degas,* R. Piper Verlag, Munich 1924, plate 26;
Georges Rivière, *Mr. Degas (Bourgeois de Paris),* H. Floury, Paris 1935, p. 19 (reproduced);
P.–A. Lemoisne, *Degas et son Œuvre,* Arts et Métiers Graphiques, Paris 1946, vol. I, no. 269 (reproduced);
F. Russoli and F. Minervo, *L'Opera completa di Edgar Degas,* Rizzoli Editore, Milan 1970, no. 264 (reproduced).

£100,000 $184,900 DM384,000 (lot 718)

VINCENT VAN GOGH

LA BERGÈRE, D'APRÈS MILLET

oil on canvas

20¾in. by 16in. 52·7cm. by 40·7cm.

Painted at St. Rémy, August–November 1889, from a reproduction of Millet's wood engraving, *La Grande Bergère assise* (Delteil no. 33). Van Gogh wrote to his brother Theo about Millet on numerous occasions, amongst which the following quotes, written during the time he was working on this picture, are of particular interest:

Letter 605, 10 September 1889: "*When I realize the worth and originality and the superiority of Delacroix and Millet, for instance, then I am bold enough to say – yes, I am something, I can do something. But I must have a foundation in those artists, and then produce the little I am capable of in the same direction*". Letter 607: "*I have now seven out of the ten of Millet's 'Travaux des Champs'. I can assure you that making copies interests me enormously, and it means that I shall not lose sight of the figure, even though I have no models at the moment*". Letter 613: "*. . . it seems to me that painting from these drawings of Millet's is much more* translating them into another tongue *than copying them*". Letter 623: "*. . . you will see clearly that they have been done out of a profound and sincere admiration for Millet. Then, whether they are someday criticized or despised as copies, it will nonetheless be true that they have their justification in the attempt to make Millet's work more accessible to the great general public*".

PROVENANCE:
Mrs. J. van Gogh-Bonger, Amsterdam.

EXHIBITED:
Rotterdam, Kunstzalen Oldenzeel, *Vincent van Gogh*, March 1896, no. 17;
Utrecht, Vereeniging voor de Kunst, *Vincent van Gogh*, 1905, no. 48;
Amsterdam, Stedelijk Museum, *Vincent van Gogh*, July–August 1905, no. 187;
Rotterdam, Kunstzalen Oldenzeel, *Vincent van Gogh*, January–February 1906, no. 43;
Cologne, *Internationale Kunstausstellung des Sonderbundes Westdeutsche Kunstfreunde und Kunstler zu Koln*, May–September 1912, no. 74;
Berlin, Paul Cassirer Gallery, *Vincent van Gogh*, May–June 1914, no. 115;
Basel, Galerie Schulthess, *Vincent van Gogh 25 Werke, Hollandhilfe*, 1945, no. 15;
Basel, Kunsthalle, *Vincent van Gogh*, October–November 1947, no. 86.

LITERATURE:
J.–B. de la Failler, *L'Oeuvre de Vincent van Gogh*, Paris and Brussels 1928, no. F 699;
W. Scherjon and W. J. de Gruyter, *Vincent van Gogh's great period. Arles, St. Rémy and Auvers-sur-Oise*, Amsterdam 1937, no. 164 (reproduced);
J.–B. de la Faille, *Vincent van Gogh*, Hyperion, Paris 1939, no. H 714 (reproduced);
Fritz Novotny, *Die Bilde van Gogh's nach fremden Vorbildern*, Berlin 1961, pp. 213–230;
J.–B. de la Faille, *The Works of Vincent van Gogh*, London 1970, no. F 699 (reproduced).

£210,000 $388,290 DM806,400 (lot 729)

VINCENT VAN GOGH

MAS À SAINTES-MARIES

reed pen and sepia ink and pencil

12in by 18½in 30·5cm by 47cm

Drawn at Saintes-Maries in June 1888.

Van Gogh did a painting of the same subject as well as another drawing, now in the Museum of Modern Art, New York (de la Faille nos. F420 and F1435).
Van Gogh wrote to his brother Theo as follows:
"And the houses – like the ones on our heaths and peat bogs in Drenthe; you will see some specimens of them in the drawings". (Letter no. 499, probably 22 June 1888)
"I have three more drawings of cottages which I still need, and which will follow these: they are rather harsh, but I have some more carefully drawn ones." (Letter no. 500, probably 23 June 1888).

PROVENANCE:
Mrs. J. Van Gogh-Bonger, Amsterdam;
Paul Cassirer, Berlin;
Joachim Zimmermann, Mittelschreiberhau;
Neumann, Wannsee;
Fritz Nathan, Zurich.

EXHIBITED:
Amsterdam, Stedelijk Museum, *Vincent van Gogh*, July–August 1905, no. 378;
Berlin, Paul Cassirer Art Gallery, *Vincent van Gogh*, May–June 1914, no. 97;
Berlin, Otto Wacker Art Gallery, Vienna, Neue Galerie and Hanover, Kestner gesellschaft, *Vincent van Gogh*, December 1927–April 1928, no. 104;
Basel, *Basler Privatbesitz*, no. 160;
Basel, Galerie Schulthess, *Vincent van Gogh 25 Werke, Hollandhilfe*, June–August 1945, no. 22;
Liège, Musée des Beaux-Arts, Brussels, Palais des Beaux-Arts and Mons, Musée des Beaux-Arts, *Vincent van Gogh*, October 1946–January 1947, no. 92;
Paris, Musée de l'Orangerie, and Geneva, Musée Rath, *Vincent van Gogh*, January–April 1947, no. 93;
Basel, Kunsthalle, *Vincent van Gogh*, October–November 1947, no. 151.

(*continued*)

LITERATURE:

Julius Meier-Graefe, *Vincent van Gogh*, R. Piper Verlag, Munich 1910, p. 69 (reproduced);

Elisabeth du Quesne-Van Gogh, *Persönlische Erinnerungen van Vincent van Gogh*, Munich 1913, reproduced on the cover;

Lettres de Vincent van Gogh à Emile Bernard, published by Ambroise Vollard, Paris 1911, plate LXXIV;

Vincent van Gogh, 16 facsimiles after drawings and watercolours, published by Hans von Marees-Gesellschaft, Munich 1919, plate IV;

H. F. E. Visser, *Some Parallels between Western and Far Eastern Art*, in "The Burlington Magazine", April 1920, p. 162 (reproduced);

Julius Meier-Graefe, *Vincent van Gogh*, Munich 1921 and 1925, vol. II, plate 56;

G. F. Hartlaub, *Vincent Van Gogh und Natur*, in "Cicerone", 1922, XIV, 16, p. 643 (reproduced);

J.–B. de la Faille, *L'Œuvre de Vincent van Gogh*, Paris and Brussels 1928, no. F1344 (reproduced);

Wilhelm Uhde, *Vincent van Gogh*, Phaidon, Vienna 1935, p. 35 (reproduced);

The Complete Letters of Vincent van Gogh, Thames and Hudson, London 1958, vol. II, letters 499 and 500;

F. Lecaldano, *Tout l'Œuvre peint de Van Gogh*, Flammarion, Paris 1971, no. 511a (reproduced);

J.–B. de la Faille, *The Works of Vincent van Gogh*, Weidenfeld and Nicolson, London 1970, no. F1434 (reproduced).

£205,000 $379,147 DM787,712 (lot 844)

EDGAR DEGAS

AU THÉÂTRE, LE DUO

pastel over monotype in black ink, signed

4⅝in by 6⅜in 11·7cm by 16·2cm

Executed *circa* 1877.

PROVENANCE:
John Lewis Brown, Paris (vente, Paris, 22 May 1919, no. 41);
Durand-Ruel, Paris and New York (purchased at the above sale and immediately sent to New York);
Knoedler & Co., New York (sold to von Hirsch in 1919).

EXHIBITED:
Basel, *Basler Privatbesitz*, no. 218.

LITERATURE:
P. A. Lemoisne, *Degas et son Œuvre*, Arts et Métiers Graphiques, Paris 1946, vol. II, no. 433 (reproduced);
Douglas Cooper, *Pastels by Degas*, Holbein Verlag, Basel 1952, colour plate 9;
Eugenia Parry Janis, *Degas Monotypes*, Fogg Art Museum, Harvard University 1968, no. 27 (reproduced).

£62,000 $114,669 DM238,235 (lot 825)

VINCENT VAN GOGH

ARLES, VUE DES CHAMPS DE BLÉ

reed pen and sepia ink, signed

12¼in by 9½in 31·2cm by 24·2cm

Drawn in the summer of 1888, there are two other drawings of the same subject and a related painting now in the Musée Rodin, Paris (de la Faille nos. F1490, 1492 and 545). Van Gogh wrote to his brother Theo as follows:
"Today I am sending you three drawings by post . . . The 'Harvest' is rather more serious. That is the subject I have worked on this week on a size 30 canvas; it isn't at all finished, but it kills everything else I have . . ." (Letter no. 498 about 16 June 1888)
"I have just sent off three big drawings, as well as some other ones, and the two lithographs by de Lemud . . . Now the Harvest, the Garden, the Sower, and the two marines are sketches after painted studies. I think all these ideas are good, but the painted studies lack clearness of touch. That is another reason why I felt it necessary to draw them . . ." (Letter 519, 8 August 1888).

PROVENANCE:
Mrs. J. van Gogh-Bonger, Amsterdam;
Gustav Engelbrecht, Hamburg (stamped with his collection mark Lugt no. 1148);
J. Freund, Berlin.

EXHIBITED:
Berlin, *Berliner Secession*, January 1908, no. 123;
Berlin, Otto Wacker Art Gallery, Vienna, Neue Galerie and Hanover, Kestner gesellschaft, *Vincent van Gogh*, December 1927–April 1928, not listed in the catalogue.
Basel, *Basler Privatbesitz*, no. 162;
Basel, Galerie Schulthess, *Vincent van Gogh 25 Werke, Hollandhilfe*, June–August 1945, no. 24;
Basel, Kunsthalle, *Vincent van Gogh*, October–November 1947, no. 161.

LITERATURE:
Vincent van Gogh, facsimiles from his drawings and watercolours, published by Hans von Marees-Gesellschaft, Munich 1928, plate XI;
J.-B. de la Faille, *L'Œuvre de Vincent van Gogh*, Paris and Brussels 1928, no. F1492 (reproduced);
The Complete Letters of Vincent van Gogh, Thames and Hudson, London 1958, vol. II, no. 498 and vol. III, no. 519;
F. Lecaldano, *Tout l'Œuvre peint de Van Gogh*, Flammarion, Paris 1971, no. 565c (reproduced);
J.-B. de la Faille, *The Works of Vincent van Gogh*, Weidenfeld and Nicolson, London 1970, no. F1492 (reproduced).

£200,000 $369,900 DM768,500 (lot 843)

GEORGES SEURAT

PÊCHEUSE À LA LIGNE AU BORD DE LA SEINE

oil on panel, stamped with the signature

6⅛in. by 9¾in. 15·5cm. by 24·8cm.

Painted *circa* 1884–85. This is a study for the woman fishing in the left of the painting, *Un Dimanche à la Grande Jatte,* in the Art Institute, Chicago.

Posthumous inventory, *Panneau* no. 95.

PROVENANCE:
Eugène Druet, Paris;
Alexandre Natanson, Paris;
Vente, Paris, Hôtel Drouot, 17 March 1911, no. 69, 160 francs;
Bernheim-Jeune, Paris;

EXHIBITED:
Paris, Galerie Bernheim-Jeune, *Rétrospective Georges Seurat,* December 1908–January 1909, no. 43;

LITERATURE:
Dorra and Rewald, *Seurat,* Les Beaux-Arts, Paris 1959, no. 113 (reproduced);
M. de Hauke, *Seurat et son Oeuvre,* Grund, Paris 1961, vol. I, no. 113 (reproduced);

£75,000 $138,675 DM288,000 (lot 728)

GEORGES SEURAT

ENSEMBLE, ETUDE POUR LA PARADE

pen and sepia ink (squared up in pencil for enlargement)

5in by 7⅜in 12·7cm by 18·7cm

Drawn in 1887, this is a very complete study for the painting *La Parade* in the Metropolitan Museum of Art, New York.

PROVENANCE:
Wildenstein & Co., London.

EXHIBITED:
London, Wildenstein & Co., *Seurat and his Contemporaries*, January–February 1937, no. 55;
Basel, *Basler Privatbesitz*, no. 222.

LITERATURE:
John Rewald, *The History of Post-Impressionism*, Museum of Modern Art, New York 1956, p. 111 (reproduced);
Henri Dorra and John Rewald, *Seurat*, Les Beaux-Arts, Paris 1959, no. 181a (reproduced);
César M. de Hauke, *Seurat et son Œuvre*, Grund, Paris 1961, vol. II, no. 681 (reproduced);
A. Chastel and F. Minervino, *Tout l'Œuvre peint de Seurat*, Flammarion, Paris 1973, no. D.64 (reproduced).

£79,000 $146,110 DM303,557 (lot 847)

BERTHE MORISOT

JEUNE FEMME EN ROBE NOIRE

watercolour and pencil, signed

5in by 3⅛in 12·7cm by 8cm

Executed in 1876.

PROVENANCE:
Alexis Rouart, Paris;
H. Martin.

EXHIBITED:
Paris, Musée de l'Orangerie, *Berthe Morisot*, summer 1941, no. 160.
Paris, Galerie Bernheim-Jeune, *Exposition d'Œuvres de Berthe Morisot*, May 1959, no. 134;

LITERATURE:
Correspondance de Berthe Morisot avec sa Famille et ses Amis, Paris 1950, colour plate facing p. 62;
M. L. Bataille and G. Wildenstein, *Berthe Morisot, Catalogue des Peintures, Pastels et Aquarelles*, Les Beaux-Arts, Paris 1961, no. 636, fig. 616.

£21,000 $38,839 DM80,692 (lot 821)

CLAUDE MONET

ETUDE D'ENFANTS

pastel, signed

8¾in by 9¼in 22·2cm by 23·5cm

Executed in Normandy in 1864.

PROVENANCE:
Durand-Ruel, Paris (1920);
Dr. Simon Meller, Budapest and Munich (1927).

EXHIBITED:
Basel, Kunsthalle, *Impressionisten*, 1940, no. 239.

LITERATURE:
William Seitz, *Claude Monet*, Harry Abrams, New York 1960, fig. 69;
M. Kuroe, *Monet*, Zauro Press, Japan 1970, p. 82 (reproduced).

£23,000 $42,538 DM88,377 (lot 819)

PAUL CEZANNE

PORTRAIT DE FORTUNÉ MARION

oil on canvas

16in by 12¾in 40·6cm by 32·5cm

Painted *circa* 1871.

Fortuné Marion was a close friend of Cézanne from the time they were at school together at the Collège Bourbon in Aix-en-Provence. A geologist and amateur painter who published a treatise on prehistoric man in Provence, he was a great supporter of Cézanne in the early years.

PROVENANCE:
Fortuné Marion, Marseille;
Mrs. Arnold Mettler (sale, Sotheby's, 17 February 1932, lot 131);
Hans Mettler, St. Gall.

EXHIBITED:
Basel, *Basler Privatbesitz*, no. 315.
Zurich, Kunsthaus, *Cézanne*, August–October 1956, no. 8;

LITERATURE:
Ambroise Vollard, *Paul Cézanne*, Paris 1914, no. 23;
Gustave Coquiot, *Paul Cézanne*, Albin Michel, Paris 1919, pp. 18, 37 and 244;
Georges Rivière, *Le Maître Paul Cézanne*, H. Floury, Paris 1923, catalogued p. 196;
Bulletin de l'Art, March 1932, p. 159 (reproduced);
Alfred Barr, *Cézanne d'après les Lettres de Marion à Morstatt, 1865–68*, in "Gazette des Beaux Arts" January 1937, pp. 37, 39 and 41 (reproduced);
Magazine of Art, February 1938, p. 87 (reproduced);
John Rewald, *Paul Cézanne*, New York 1948, fig. 20;
John Rewald, *Paul Cézanne*, London 1959 and 1965, pp. 64 and 67, plate 9;
S. Orienti and A. Gatto, *L'Opera completa di Cézanne*, Rizzoli Editore, Milan 1970, no. 83 (reproduced);
Venturi, *Cézanne*, no. 129 (reproduced).

£150,000 $277,350 DM576,000 (lot 714)

PAUL CEZANNE

BAIGNEUSES, LA MONTAGNE SAINTE-VICTOIRE AU FOND

watercolour and pencil

5in by 8½in 12·7cm by 21·6cm

Executed *circa* 1902–06, this is a page from a sketchbook. On the reverse there is a pencil sketch of a house.
It is one of the latest and most advanced of Cézanne's studies of bathers and is closely related to the oil painting, Venturi no. 725.

PROVENANCE:
Paul Cézanne fils, Paris;
Dr. Otto Wertheimer, Paris.

EXHIBITED:
Paris, Galerie Renou et Poyet, *Aquarelles et Baignades de Cézanne*, June 1935;
Zurich, Kunsthaus, *Cézanne*, August–October 1956, no. 141.

LITERATURE:
Jean Cassou (préface), *Album Cézanne*, Editions des Quatre Chemins, Paris 1947, plate 3;
Francis Jourdain, *Cézanne*, Paris 1950, reproduced;
Melvin Waldfogel, *A Problem in Cézanne's Grande Baigneuses*, in "The Burlington Magazine", May 1962, fig. 37;
Venturi, *Cézanne*, no. 1108 (reproduced).

£140,000 $258,930 DM537,950 (lot 835)

PAUL CEZANNE

NATURE MORTE AU MELON VERT

watercolour and pencil

12⅜in by 18¾in 31·5cm by 47·5cm

Executed *circa* 1900–05.

PROVENANCE:
Ambroise Vollard, Paris;
Edouard Jonas, Paris;
Paul Rosenberg, New York (sold to von Hirsch in October 1949).

LITERATURE:
Georg Schmidt, *Aquarelle von Cézanne*, Holbein Verlag, Basel 1952, colour plate 25;
Venturi, *Cézanne*, vol. I, p. 350, catalogued but not reproduced as Venturi was unable
to obtain a photograph.

£300,000 $554,850 DM1,152,750 (lot 836)

PAUL CEZANNE

FEMME ASSISE

watercolour and pencil

18$\frac{7}{8}$in by 14$\frac{1}{4}$in 48cm by 36cm

Executed *circa* 1902–04.
The model appears to be identical with the one that posed for an unfinished painting,
Venturi no. 1611, of 1902–04.

PROVENANCE:
Ambroise Vollard, Paris (Vollard archives no. 194);
Private collection, London;
Paul Rosenberg, New York (sold to von Hirsch in November 1951).

LITERATURE:
Ambroise Vollard, *Paul Cézanne*, Paris 1914, p. 125 (reproduced);
Lionello Venturi, *Paul Cézanne Watercolours*, Bruno Cassirer, Oxford 1944, plate 14;
William Rubin editor, *Cézanne – The late Work*, Museum of Modern Art, New York
1977, plate 21;
Venturi, *Cézanne*, no. 1093 (reproduced).

£120,000 $221,940 DM461,100 (lot 838)

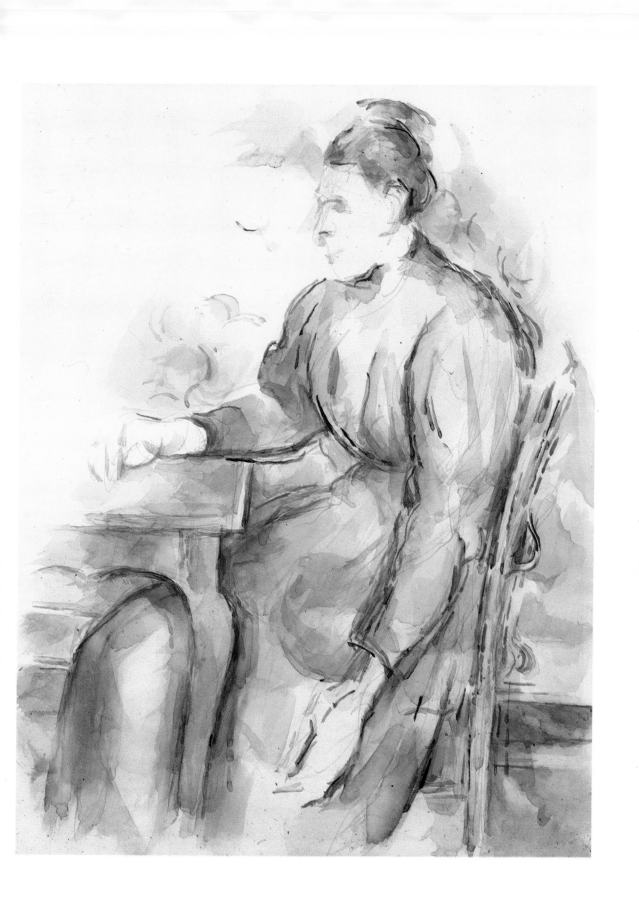

PAUL CEZANNE

ARBRES AU BORD D'UNE ROUTE

watercolour and pencil

18⅜in by 12in 46·7cm by 30·5cm

Executed *circa* 1900–1905.

PROVENANCE:
Ambroise Vollard, Paris (Vollard archives no. 132);
Dr. Walter Feilchenfeldt, Zurich (purchased from Vollard in 1938 and sold to von Hirsch in July 1951).

EXHIBITED:
London, Paul Cassirer, *Paul Cézanne Watercolours*, July 1939, no. 7.

LITERATURE:
Georg Schmidt, *Aquarelle von Cézanne*, Holbein Verlag, Basel 1952, colour plate 16.

To be included in the *Catalogue Raisonné* of the Cézanne Watercolours being prepared by John Rewald and Adrien Chappuis.

£110,000 $203,445 DM422,675 (lot 841)

CAMILLE PISSARRO

PORTRAIT DE PAUL CÉZANNE

oil on canvas

28¾in by 23½in 73cm by 59·7cm

This portrait of Cézanne was probably painted in the first months of 1874 in Pissarro's studio at Pontoise, during the time that Cézanne and Pissarro were working closely together. Cézanne said about Pissarro: *"Ce fut un père pour moi . . . et quelquechose comme le Bon Dieu"*. Hanging on the wall behind Cézanne there are two caricatures, one titled *La Délivrance* by André Gill, which appeared on 4 August 1872 in the newspaper *L'Eclipse,* the other a caricature of Courbet by Léonce Petit which appeared on 13 June 1867 in *Le Hanneton,* and below it part of Pissarro's landscape, *La Maison du Père Galien à Pontoise,* of 1873 (L.-R. Pissarro and L. Venturi, no. 206). This same picture also appears pinned to the wall in the background of a still life by Cézanne (Musée du Jeu de Paume, no. 494) which he must have painted in Pissarro's studio, probably in 1875. This portrait of Cézanne ties in closely with Cézanne's own self portrait (Venturi, no. 288) and Pissarro's etched portrait of Cézanne (Delteil, no. 13). This was one of Pissarro's favourite pictures and was still hanging in his studio at Eragny towards the end of his life.

PROVENANCE:
According to John Rewald, it was probably sold by Pissarro's widow.

EXHIBITED:
Bremen, Kunsthalle, *Internationale Kunstausstellung,* February–March 1910, no. 265;
Leipzig, Kunstverein, *Die französische Ausstellung,* October–November 1910;
Paris, Galerie Manzi-Joyant, January–February 1914, no. 43;
Basel, *Basler Privatbesitz,* no. 244.
Paris, Orangerie des Tuileries, *Van Gogh et les Peintres d'Auvers-sur-Oise,* November 1954–February 1955, no. 94 (reproduced in the catalogue);

(continued)

LITERATURE:

Georg Biermann, *Die Ausstellung französische Kunst im Leipziger Kunstverein,* in "Der Cicerone", Leipzig, 12 October 1910, p. 678 (reproduced);

Anna Rechberg, *Die französische Ausstellung im Leipziger Kunstverein,* in "Zeitschrift für bildenden Kunst", Leipzig, November 1910, p. 45 (reproduced);

S. Winsten, *Camille Pissarro at the Leicester Galleries,* in "Voices", London, June 1920, reproduced;

A New Critic, *Growing by Experiment,* in "Drawing and Design", London, October 1920, p. 169 (reproduced);

Partisans, Paris, April 1924, reproduced;

Charles Kunstler, *Camille Pissarro,* G. Crès Editeurs, Paris 1930, p. 6 (reproduced);

La Peinture française du XIX siècle, Braun Editeur, Paris 1934, vol. III, reproduced;

L'Amour de l'Art, numéro spécial sur Cézanne, edited by R. Huyghe and J. Rewald, May 1936, p. 161 (reproduced);

John Rewald, *Cézanne et Zola,* Paris 1936, fig. 20;

Fritz Novotny, *Cézanne,* Phaidon, Vienna 1937, p. 18 (reproduced);

Ludovic-Rodo Pissarro and Lionello Venturi, *Camille Pissarro, Son Art–Son Œuvre,* Paul Rosenberg Editeur, Paris 1939, no. 293 (reproduced);

John Rewald, *Cézanne, sa Vie, son Œuvre, son Amitié pour Zola,* Paris 1939, fig. 36;

Camille Pissarro, *Letters to his son Lucien,* edited by John Rewald, Pantheon Books, New York 1943 and 1972, fig. 51;

John Rewald, *The History of Impressionism,* Museum of Modern Art, New York 1946, p. 247 (reproduced), 1961 and 1973 editions, p. 298 (reproduced);

John Rewald, *Paul Cézanne – a Bibliography,* New York 1948 (and subsequent editions), fig. 43;

Gotthard Jedlicka, *Pissarro,* Alfred Scherz Verlag, Bern 1950, colour plate 9;

Douglas Cooper, *The Painters of Auvers-sur-Oise,* in "The Burlington Magazine", April 1955, reproduced facing p. 99;

Paul Gachet, *Lettres Impressionnistes au Dr. Gachet et à Murer,* Grasset, Paris 1957, p. 62 (reproduced);

John Rewald, *Cézanne and Zola,* Spring Books, London 1959 and 1965, fig. 31;

John Rewald, *Camille Pissarro,* Harry N. Abrams, New York 1963, p. 25 (reproduced); see p. 41 for a photograph taken inside Pissarro's studio at Eragny where this picture is shown hanging high on the wall;

Lucien Pissarro, undated letter to his brother Paul-Emile published in W. S. Meadmore, *Lucien Pissarro, un Cœur simple,* Constable, London 1962, pp. 25–6. In this letter Lucien describes this portrait and writes about Cézanne's physical characteristics in 1874;

Theodore Reff, *Pissarro's Portrait of Cézanne,* in "The Burlington Magazine", November 1967, pp. 627–633, reproduced facing p. 627.

£300,000 $554,700 DM1,152,000 (lot 715)

PABLO PICASSO

ETUDES DE PERSONNAGES

pen and ink and watercolour heightened with white, signed

9¾in by 12⅝in 24·8cm by 32cm

Executed *circa* 1904–05, the figures of the woman and of the man are similar to figures in two drawings in the Picasso estate.

£24,000 $44,388 DM92,220 (lot 856)

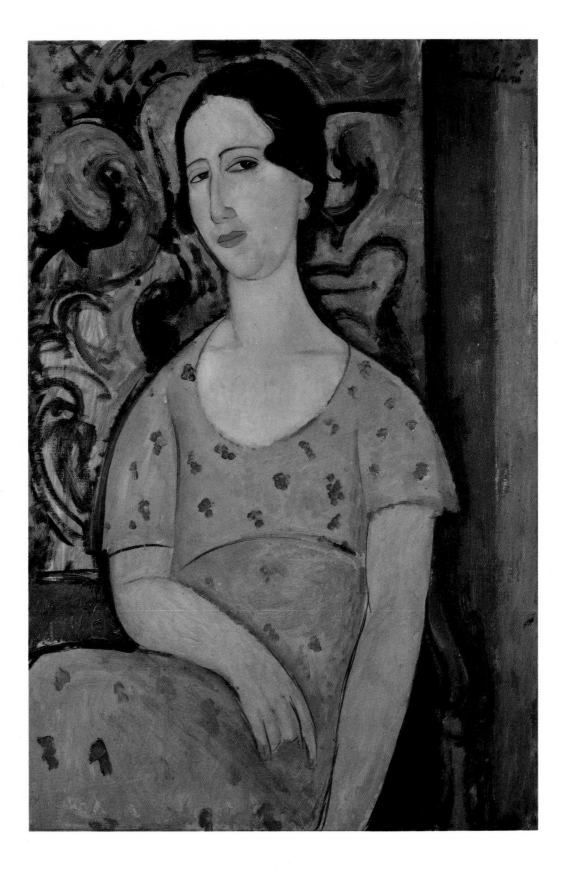

AMEDEO MODIGLIANI

JEUNE FEMME À LA ROBE JAUNE (MADAME MODOT)

oil on canvas, signed

36¼in by 23½in 92cm by 59·5cm

Painted in Nice in October 1918.

PROVENANCE:
Léopold Zborowski, Paris;
Bernheim-Jeune, Paris (purchased from Zborowski on 6 June 1922);
Madame Guérin, Paris (purchased on 9 April 1923);
Jean Netter, Paris;
Galerie Bing, Paris.

EXHIBITED:
Zurich, Kunsthaus, *Modigliani*, March–April 1930, no. 141.
Venice, *XVII Esposizione Biennale Internazionale da Modigliani*, 1930 (no. 306 in the 1930 photographic library of the Biennale);
Brussels, Palais des Beaux-Arts, *Modigliani*, November 1933, no. 32;
Basel, Kunsthalle, *Modigliani*, January–February 1934, no. 24.

LITERATURE:
Arthur Pfannstiel, *Modigliani*, Editions Marcel Seheur, Paris 1929, catalogued p. 47;
G. di San Lazaro, *Modigliani, Peintures*, Les Editions du Chêne, Paris 1947 (2nd edition 1953), colour plate 14;
G. Scheiwiller, *Amedeo Modigliani*, Milan 1950, plate 37;
Pierre Descargues, *Amedeo Modigliani*, Editions Braun, Paris 1951 (2nd edition 1954), colour plate 43;
Arthur Pfannstiel, *Modigliani et son Œuvre*, Paris 1956, catalogue raisonné no. 284, p. 147;
Ambrogio Ceroni, *Amedeo Modigliani, Dessins et Sculptures avec suite du catalogue illustré des Peintures*, Edizione del Milione, Milan 1965, no. 203 (reproduced);
Ambrogio Ceroni, *I Dipinti di Modigliani*, Rizzoli Editore, Milan 1970, no. 283 (reproduced);
Jeffrey Robinson, *Modeling for Modigliani*, in the *International Herald Tribune*, 21 August 1974, reproduced with a photograph of Renée Modot taken in 1974. In this article Madame Modot describes sitting for Modigliani's paintings, including this one.

£165,000 $305,085 DM633,600 (lot 743)

HENRI MATISSE

NATURE MORTE À LA DORMEUSE

oil on canvas, signed and dated '40

31⅞in by 39⅞in 81cm by 100cm

Madame Marguerite Duthuit writes, in a letter dated 1 February 1978, that Matisse described this picture as follows: "*Dormeuse en blouse roumaine posée sur une table violette, fruits et feuillages, grande toile au mur du fond – Nice 1940–40 Fig.*", and notes that he finished it on 22 December 1939 and signed it on 6 January 1940.
There are quite a number of drawings which Matisse drew in 1939–40, not as studies for this picture but as parallel works in another medium.

PROVENANCE:
Paul Rosenberg, New York (purchased from the artist in March 1940 and sold to von Hirsch in November 1951).

EXHIBITED:
Brussels, Palais des Beaux-Arts, *Matisse–Picasso*, 1946, no. 12 (incorrect measurements).

LITERATURE:
Pierre Courthion, *Le visage de Matisse*, Editions Marguerat, Lausanne 1942, p. 84 (reproduced);
Cahiers d'Art, Numéro spécial sur Matisse, 1940–44, p. 128 (reproduced);
Georges Besson, *Matisse*, Collection des Maîtres, Editions Braun, Paris 1945, plate 46;
Gaston Diehl, *Henri Matisse*, Editions Pierre Tisné, Paris 1958, plate 126.

£310,000 $573,190 DM1,190,400 (lot 751)

PAUL KLEE

GESTIRN ÜBER BÖSEN HÄUSERN

tempera on linen laid down on board, signed; titled and dated 1916 79 on the mount

7⅞in by 8⅝in 20cm by 22cm

This work is recorded under no. 1916/79 in Klee's own *Œuvre Catalogue*.

PROVENANCE:
Herwarth Walden, Berlin;
Nell Walden, Ascona;
Gustav Zumsteg, Zurich.

EXHIBITED:
Berlin, *Kunstausstellung der Sturm*, February 1917, no. 34;
London, New Burlington Gallery, *Modern German Art*, 1938, no. 46/1;
Basel, Kunstmuseum, *Klee*, 1952, no. 107;
Basel, Galerie Beyeler, *Maîtres de l'Art Moderne*, 1955, no. 17.

LITERATURE:
Paul Klee gemälde, Verlag Ernst Vollmer, Wiesbaden 1955 or 1956, plate 2.
Histoire de la Peinture moderne, de Picasso au Surréalisme, Skira, p. 100 (reproduced in colour).
L. G. Buchheim, *Der Blaue Reiter*, Felvafing, 1959, p. 249 (reproduced).

£70,000 $129,430 DM268,800 (lot 749)

GEORGES BRAQUE

NATURE MORTE

watercolour, charcoal and pencil, signed on the margin

6½in by 5½in 16·5cm by 14cm

Executed *circa* 1917–18.

To be included in the *Braque Œuvre Catalogue des Aquarelles et Dessins* being prepared by Madame Worms de Romilly and published by Maeght.

£20,000 $36,990 DM76,850 (lot 859)

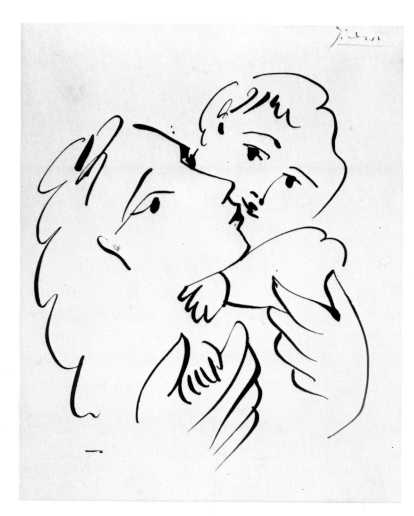

PABLO PICASSO

MÈRE ET ENFANT

brush and indian ink, signed

10in by 8in 25·5cm by 20·3cm

Drawn in 1951.

PROVENANCE:
Galerie Louise Leiris, Paris.

£12,500 $23,118 DM48,031 (lot 877)

ABBREVIATIONS APPLICABLE TO IMPRESSIONIST

AND MODERN ART (pages 117–159)

Basler Privatbesitz Basel, Kunstmuseum, *Ausstellung von Werken des 19. Jahrhunderts aus Basler Privatbesitz*, May–June 1943.

Chappuis Adrien Chappuis, *The Drawings of Paul Cézanne, a Catalogue Raisonné*, Thames and Hudson, London 1973.

Dortu M. G. Dortu, *Toulouse-Lautrec et son Œuvre*, Collectors Editions, New York 1971.

Venturi Lionello Venturi, *Cézanne, Son Art – Son Œuvre*, Paul Rosenberg Editeur, Paris 1936.